# Secret Victorians

## ICTORIANS

### CONTEMPORARY ARTISTS AND A 19TH-CENTURY VISION

National Touring Exhibitions

sbc

Published on the occasion of *Secret Victorians*: *Contemporary Artists and a 19th-Century Vision*, a National Touring Exhibition organised by the Hayward Gallery, London, for the Arts Council of England.

**Exhibition tour**

Firstsite, The Minories Art Gallery, Colchester
17 October - 5 December 1998

Arnolfini, Bristol
12 December - 31 January 1999

Ikon Gallery, Birmingham
10 February - 4 April

Middlesbrough Art Gallery, Middlesbrough
1 May - 26 June

UCLA at the Armand Hammer Museum of Art
and Cultural Center
20 September - 2 January 2000

Exhibition curated by Melissa E. Feldman and Ingrid Schaffner
Exhibition organised by Roger Malbert, assisted by Julia Risness and Jessica White

Catalogue designed by Alexander Boxill
Printed by in England by Balding + Mansell Limited

**Front cover**
Simon Periton, *Queen Victoria*, 1997 (cat. 38)
© the artist, courtesy Sadie Coles HQ, London

**Back cover**
Sally Mann, *At Warm Springs*, 1991 (cat. 26)
© Sally Mann, courtesy Edwynn Houk Gallery, New York

Published by Hayward Gallery Publishing, London SE1 8XX
© The South Bank Centre 1998
Essay © Melissa E. Feldman and Ingrid Schaffner 1998

ISBN 1 85332 186 9

National Touring Exhibitions, Hayward Gallery and Arts Council Collection publications are distributed by Cornerhouse Publications, 70 Oxford Street, Manchester M1 5NH (tel. 0161 200 1503; fax. 0161 237 1504).

# PREFACE

The idea of uniting twenty British and American artists under the banner of 'the Victorian' may seem risky, particularly on this side of the Atlantic where that term has exceedingly complicated, and not altogether favourable, associations. Yet a glance at the list of artists included in *Secret Victorians* should be sufficient to reassure the sceptical that this is not a celebration of the nostalgic and overwrought; there is a concentration of imaginative energy, wit and irony here that will delight every lover of contemporary art.

*Secret Victorians* brings to Britain a number of American artists who have been little seen here, and we are grateful to the curators, Melissa Feldman and Ingrid Schaffner, for initiating the exhibition and for making such a judicious selection. We also thank the artists, who have responded with such openness to our invitation to participate, and the lenders who have generously agreed to part with works for an exceptionally long tour.

At the project's inception, the curators benefited from a Research and Development grant from the Arts Council of England. The exhibition was planned in its early stages as a collaboration with Ikon Gallery, whose Director, Elizabeth A. Macgregor, and Curator, Claire Doherty, were quick to recognise its potential and particular relevance to the city of Birmingham. The opportunity to work with Birmingham Museum and Art Gallery, siting certain of the works there during Ikon's showing and sharing the educational programme, is extremely welcome. We also thank our colleagues at Firstsite and Arnolfini for their valuable contributions to our thinking on the presentation and interpretation of exhibition. We are delighted that the curators' ambition of a transatlantic tour has been realised, thanks to the participation of the Armand Hammer Museum of Art and Cultural Center. I also extend my warmest thanks to my colleagues at the Hayward Gallery and the South Bank Centre who have helped to organise this exhibition and in particular to Roger Malbert, the Hayward's Senior Curator, National Touring Exhibitions, for bringing it to fruition with such dedication and enthusiasm.

**Susan Ferleger Brades**
Director, Hayward Gallery

# Secret Victorians

## CONTEMPORARY ARTISTS AND A 19TH-CENTURY VISION

Melissa E. Feldman and Ingrid Schaffner

# INTRODUCTION

**S**ecret Victorians illuminates a nineteenth-century sensibility that is flourishing within British and American contemporary art. The Victorian period tends to conjure an era of prim morality, excessive decoration and industrial soot. But look a little closer - for example, at the accomplishments of Lewis Carroll, Charles Darwin, Charles Dickens, George Eliot and Edward Lear, to name only a few eminent Victorians - and the period comes to epitomize the highest standards of intellectual curiosity and imaginative freedom. It is according to these models of eccentricity, ingenuity and complexity that one can discern the most intriguing aspects of Victorian sensibility, and identify concerns which are hidden within today's art.

In 1868, the critic Walter Pater warned his Victorian peers against strict revivalism in art, emphasizing the value of interpretation over reproduction. With similar caution, Secret Victorians features art that evokes, not mimics, the Victorian through its imagery, materials or processes. Given its breadth, it would be sheer folly to attempt to define the period with any accuracy. Queen Victoria reigned from 1837 to 1901, during which time incredible changes took place. Among these were a profusion of technological innovations that helped to fuel the industrial age, just as a centuries-old agrarian era went into eclipse. In culture, romanticism and historicism were the underlying intellectual currents that precipitated innumerable styles and sub-styles.

The first question must be what 'the Victorian' means today. In Britain, artists invited to participate in this exhibition, with its Victorian context, generally seemed wary of a term that connotes stern brick buildings, urban poverty, colonialism, inferior plumbing and, more recently, the values of Thatcherism. In America (from where both curators originate), the associations are lighter, less socio-political than cultural, and artists welcomed the suggestive paradigm of parlour games and overwrought architecture, cosiness and claustrophobia. For Americans, the leading literary stylists of the period were largely British. Both Charles Dickens and Oscar Wilde toured the United States, and they were wined, dined and mobbed at every stop; they were literary stars.

America may have declared itself a sovereign nation and a democracy, but during the nineteenth century, the term 'Victorian' still signified a common culture dominated by Britain under its Queen.

In order to characterize the Victorian sensibility, *Secret Victorians* is organized around a series of interdependent themes: Ornament & Sexuality; Photography & Death; Collecting & Colonialism; Science & Crime. As the headings under which we have grouped the contemporary works, these are by no means finite categories: artists are not locked into them. Intimately involved with scientific subjects and technology, Helen Chadwick is included here in Science & Crime, but her photographs of microbiological matter and human pre-embryos would equally apply to Photography & Death. Jane Hammond, whose work encompasses a world of appropriated images, is addressed under Collecting & Colonialism, and yet, given the sensuality of her compositions, they could as easily have operated under Ornament & Sexuality. Each pair of themes implies a sense of conflict. This is intentional, inspired by the act of revision that aims to retrieve the opposite of a commonly accepted version of history, through the revelation of lost details, forgotten facts or suppressed contexts. In other words, by addressing the concept of the Victorian through contemporary art, we are interested in seeing what it might actually have come to mean during the post-modern period.

In America and Britain today, there seems to be considerable currency in Victorian revisionism, judging from a spate of recent essays, films and biographies. These include,

for example, a discussion of Louisa May Alcott's classic novel *Little Women*. Alison Lurie restores the original subtext - 'a radical manifesto' based on the Suffragette author's committed feminism - to a tale which has come to epitomize conservative family values.[1] Simon Schama, reviewing the film *Mrs. Brown*, delved even further into the Queen's proclivity for keeping handsome male servants to hand. He tells of her very un-Victorian affection for the 'brown Brown', Abdul Karim, who succeeded the Scot, John Brown: 'she brushed aside all objections . . . especially from her Indian nobles, as "race prejudice" (which, in part, it certainly was).'[2] In a fascinating re-reading of Dickens' *David Copperfield*, Peter Gay takes on a fictitious character, Agnes Wickfield. Long held in ridicule by critics, who have scoffed at her passive devotion to David and mocked her strange habit, whenever words failed, of pointing heavenward, Gay proposes that for Agnes, 'being very good, almost beyond realistic human possibilities, was her way of denying that she was very bad'.[3]

The Victorians were perhaps less virtuous and more earthy than has traditionally been thought, and recognizing this makes it easier to identify with them. First, however, we have to rescue the Victorian from modernism. Beginning with Bloomsbury, English modernists asserted their avant-gardism by sneering at the Victorians. Indeed, modernity has typically been defined as being everything that Victorian was not: Victorians were sexless, moderns were sexual; Victorians were ornamental, moderns were streamlined; Victorians were verbose, moderns were crisp; Victorians were sentimental, moderns were analytical; and so forth.[4] And yet, of course, the key figures of early modernism - Virginia Woolf, Gertrude Stein, Sigmund Freud, James Joyce, Henri Matisse - *were* all Victorians; their formative experiences came out of the nineteenth century.

**Notes**

1  Alison Lurie, 'She Had It All', *The New York Review of Books*, March 2, 1995, pp. 3-5.

2  Simon Schama, 'Balmorality: Queen Victoria's very un-Victorian ways', *The New Yorker*, August 11, 1997, p. 41.

3  Peter Gay, 'The Legless Angel of "David Copperfield": There's More to Her Than Victorian Piety', *The New York Times Book Review*, January 22, 1995, p. 23.

4  Just as this exhibition argues for a more complex view of the Victorian, it would suggest that the modern period is also more nuanced than has been traditionally assumed.

In psychoanalysis, the patient strives to come to terms with his or her identity largely through analysis of memories from the past. Episodes from childhood are essential keys. In a sense, the Victorian era is the childhood of modernism's dark twin: surrealism. Inspired in part by Freud, the surrealists probed their subjective realities based on an imagery of dreams, anxieties, humour and intuition. And with their love of books, parlour games, ephemera, fetishes and other curiosities, they were intensely Victorian.[5] Indeed, surrealism quietly reverberates throughout *Secret Victorians*, from the automatic writing of Elliott Puckette to the anti-photography of Steven Pippin.

Not since surrealism have artists dared to re-envision the forces of the feminine, which are so typically Victorian - for it was the feminization of culture that largely accounts for the era's refutation by modernism. Epitomized by the cult of domesticity, feminine culture strikes a sentimental or hysterical note and makes fluid the boundaries between the fine and applied arts. Among the works in *Secret Victorians*, a semblance of the drawing room begins to emerge, with Mat Collishaw's and Saint Clair Cemin's furniture sculpture, Suzanne Bocanegra's whatnots, Louise Hopkins' paintings on furnishing fabric and Joan Nelson's wallpaper - an environment, perhaps, inhabited by Yinka Shonibare's mannequins clothed in nineteenth-century garb and by Sally Mann's cavorting children. The current artistic revival of interest in women's work and personal content reaches beyond feminist art of the 1960s, to the journals and hobbies of the nineteenth-century woman. Joan Nelson may borrow landscape imagery from the Hudson River School's epic-scale landscape paintings, but her delicate miniatures are equally indebted to the flora and fauna reproduced on a teacup. Simon Periton exaggerates the feminine sensibility prevalent in the decorative schemes of Augustus Pugin and Christopher Dresser, among others, by using these period designs as templates for cutting large wall-mounted paper doilies. Unabashed ornamentalism propels Lari Pittman's riotous graphics.

5   The imaginative connection to the Victorian is especially vivid in surrealist typography, composed, like Ernst's *The Hundred Headless Woman* (published 1929), from nineteenth-century sources or confected to resemble them.

Penetrating the screen that has traditionally separated the Victorian period from the modern might allow us to appreciate further parallels with the past. The spirited quest for novelty and consumer goods among a prospering leisure class of the late nineteenth century finds its corollary in today's economic boom. The conflict between the hand-made and the mass-produced, which preoccupies today's commodity-conscious artists, finds a parallel with the Industrial Revolution and its detractors in the Arts and Crafts Movement. The Victorian decorative arts are a confusing *mélange* of revivalisms, and of styles raided from all over the globe. Post-modern appropriation and pluralism can likewise be seen as contemporary versions of Victorian imperialism and eclecticism. Seen in this light, appropriation is more sanguine and less pallid than conventional post-modernism would have it. Instead of signs exhausted of meaning through over-circulation, *Secret Victorians* recasts appropriation as an inquisitive, imaginative means of reconnoitring with history, geography and different areas of knowledge. Preoccupied with morals, mortality and sex, predisposed toward pastiche and empirical investigation, and enthralled by technology, post-modernists disclose a decidedly turn-of-the-century turn of mind.

*MF/IS*

# ORNAMENT

In his brilliant study of nineteenth-century pornography, *The Other Victorians* (1964), literary historian Steven Marcus dedicated two full chapters to *My Secret Life*, the sexual memoirs of a gentleman told in eleven volumes. Another chapter is devoted to 'the immense literature - the veritable flood of publications during the Victorian period of works devoted to describing the experience of flagellation'.[6] There is more in Marcus's book to confirm Michel Foucault's claim, in his *History of Sexuality* (1976), that the Victorian period was just the kind of repressive environment in which sex finds its most insistent expression. But is this expression found in everyday cultural life? Judging from the excesses of the typical Victorian interior, ornament seems a good place to look.

'Repressive' is the word that sculptor **Saint Clair Cemin** recently used to characterize the contemporary artworld: 'I have the impression that every five years every new generation comes up with more restrictions'.[7] Defiantly levelling his sights at 'what is not art', Cemin draws on a wide range of sources: *Tea Bell*, 1990 (cat. 6), *Tea Club*, 1993 (cat. 7) and *Untitled (Cut-out)*, 1993 (cat. 8) evoke Persian, Indian, and Islamic decorative arts, stream-lined modernity, a dressing room screen, English high tea, arms and armour, wallpaper, Matisse's cutouts and Giacometti's figures. Cemin's only unbending principle is touch: the work must 'feel' right, in terms of its 'temperature' (for him, colours, materials and images are relatively hot or cold) and as a 'body'. His works ultimately stand as sensual objects, bearing the traces of handling, caressing, squeezing and, occasionally, cruel laceration.

6   Steven Marcus, *The Other Victorians: A Study of Sexuality and Pornography in MidNineteenth-Century England*, 1964, Basic Books, New York, p. xiv.

7   Interview by Shirley Kaneda, 'Saint Clair Cemin', *Bomb Magazine*, Spring 1994, pp. 52-57.

Cemin's post-modern approach is the antithesis of the classical principle of harmony as theorized during the Renaissance by Leon Battista Alberti.[8] To use Alberti's own metaphors, the gleaming, (masculine) 'body' of architecture should find a 'wife' in modest decoration, not an improperly ornamented 'whore', who 'excites numerous lustful men' until she 'falls into real disgrace'. The typical Victorian interior was, to quote critic Mitchell Owens, 'an undisciplined goulash of decorating styles' of furnishings and ornaments in a riot of colour thanks to the lurid tones of the newly introduced chemical dyes.[9] Dense, crowded compositions were the order of the day - **Joan Nelson**'s wallpaper design, almost impenetrable with vegetal energy, would have readily fitted the bill, as would **Lari Pittman**'s paintings. Eschewing the Renaissance principle of three-point perspective, Pittman's works are aggressively frontal and writhing with ornament, as if to level the viewer with their sexual charge. Beyond its Victorian prettiness, the surface of *This Discussion, Beloved and Despised, Continues Regardless*, 1989 (cat. 42) is supercharged and fibrillating with drips, squirts and veiny calligraphics. Four figures, copied from nineteenth-century silhouettes, are assembled: the two women civilly converse, while the two men are playing a whole other game, their extravagantly large penises oozing beneath the chess table. Expressing and deciphering the encoded language of homosexuality was an art-form during the Victorian era, as epitomized by Oscar Wilde's famously eloquent and moving speech, given in his own defence against charges of sodomy, about 'the Love that dare not speak its name'. In Pittman's art, polymorphous sexuality and homosexual tendencies are outrageously and deliciously apparent.

Sexuality

8    cf. Mark Wigley, 'Untitled: The Housing of Gender' in Beatriz Colomina (ed.), *Sexuality & Space*, 1992, Princeton Architectural Press. The Alberti quotes are taken from this essay.

9    Mitchell Owens, 'The Boy Wonders of Victoriana', *The New York Times*, April 27, 1995, p. C4. In his review of an exhibition of furniture by the Herter Brothers held at the Metropolitan Museum of Art, New York, Owens describes them as the exception to the image of 'overstuffed furniture, oppressive bibelots, overbaked architecture' which typifies our current notion of the era.

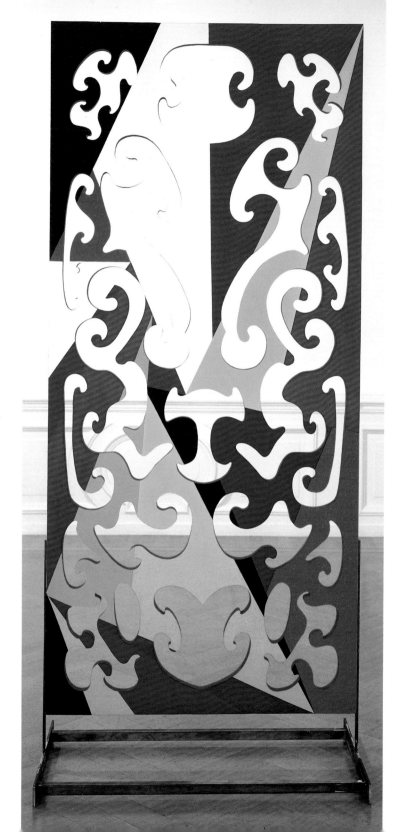

8
**Saint Clair Cemin**
*Untitled (Cut-out)*, 1993

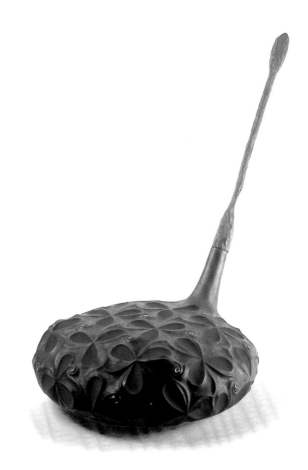

7
**Saint Clair Cemin**
*Tea Club*, 1993

42
**Lari Pittman**
*This Discussion, Beloved and Despised, Continues Regardless*, 1989

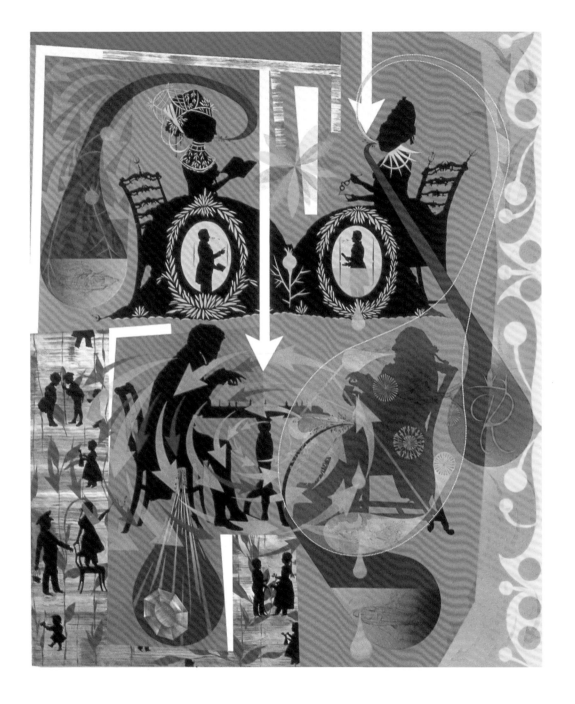

43
**Lari Pittman**
*Miraculous and Needy*, 1991

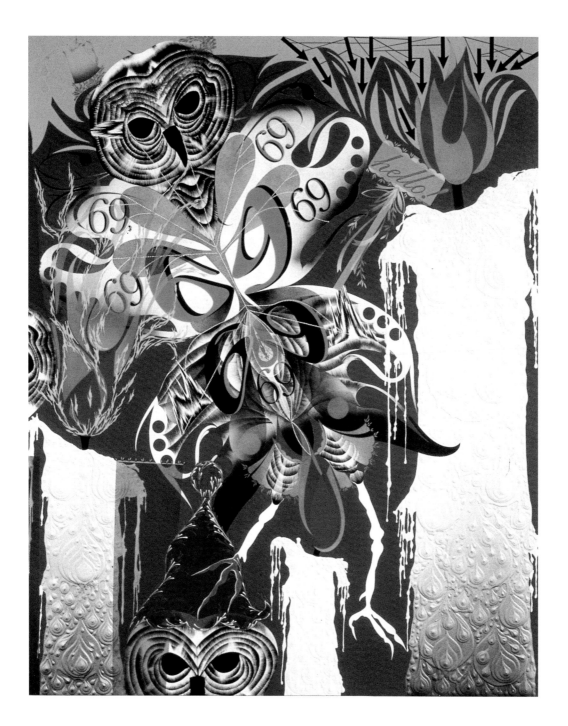

A departure from her paintings, Joan Nelson's *Wallpaper*, 1991 (cat. 31) was produced for A/D, a gallery based in New York committed to working with artists to create utilitarian objects. During the nineteenth century, William Morris, a leader of the Arts and Crafts Movement, founded Morris & Company to bring fine arts aesthetics and seriousness to the ornamentation of everyday life. The company produced tapestries and stained-glass windows based on designs by the Pre-Raphaelite artist, Edward Burne-Jones. Morris himself remains one of the Victorian era's most celebrated designers, whose fabric and wallpaper designs are still made. At the time he created the work included in *Secret Victorians*, artist **Jeffrey Dennis** resided in Leytonstone, near to Morris' childhood home in Walthamstow. Dennis' painting is titled after Morris' fantasy novel *News from Nowhere*. It is one of a series of pictures whose backgrounds depict exploded fragments of Morris & Company wallpaper. In Morris' fiction, a utopia is visited by way of a trip down the River Thames where prospects of communal happiness are envisioned at every bend. In keeping with Morris' own ideals, his wallpaper was designed to cover over the ugliness of contemporary urban life with patterns drawn from nature and medieval art. In Dennis painting (cat. 17), shaped like a snaking river, Morris' vision appears crumbled, yet enduring. The wallpaper is part of a rubble-strewn backdrop for random lengths of plumbing that bend at miniature vignettes of urban life - waiting for a bus or tram - combined with scenes of Morris' Oxfordshire home in Kelmscott.

The Arts and Crafts Movement was a worthy attempt to slow the pace of change down, at least within the domestic sphere, against the advance of industrialization. It was also subject to paradox. The *Craftsman* magazine instructed American readers to weave their own linens, embroider them with inspirational aphorisms and hang them on hand-forged towel racks. It makes the activities of today's home improvers, such as Martha Stewart with her American magazine giving instructions on how to raise pedigree chickens and to bake architecturally-correct Victorian houses out of gingerbread, appear unexceptional. **Louise Hopkins'** art brings to the surface some further anxieties and ambitions attending the Victorian decorative urge. Hopkins paints on upholstery fabrics which have been printed commercially with tasteful floral patterns that are based on historic designs, signifying cultivated living (cat. 22). Though not strictly Victorian, these traditional prints have been available cheaply since the nineteenth century, when it was possible then, as now, for even the most

middle-class home to have a touch of the château by way of the curtains and sofa. Hopkins paints on the back of the fabric, colouring in the outlined areas to produce intricate motifs that are at once hand-crafted objects and mass-produced commodities, precious and repetitive, original and by rote.

Painting flowers on china, practising calligraphy and cutting silhouettes were among the ornamental pursuits in which Victorian women were encouraged to acquire some proficiency. Artists **Elliott Puckette** and **Simon Periton** make contemporary work based on outmoded feminine pastimes that appear to have run amok, hinting at a certain perversity already inherent in them. Periton makes large-scale decorative silhouettes from paper that has first been folded, before it is intricately cut, then opened into a complex, symmetrical design (cats. 37, 38). His technique inspires awe; it is also slightly perturbing in the way that doilies, so laboriously made, can often seem simply overwrought. Any such feelings are amplified in Periton's imagery, which is gothic in nature: a pair of tubercular lungs, an abstract homage to Queen Victoria in mourning (as she was for 39 years), an owl. The gothic remains one of the Victorian period's quintessential styles. With its morbid reverence for the artifice of death and decay, it finds a current incarnation in the aesthetics of Punk and Heavy Metal music culture. Thus the bizarre union of great-grandmother and anarchic youth finds a pretty emblem in Periton's paper lace.

The grand dame of punk, Vivienne Westwood, remembers that, as a child, while practising her penmanship, 'I'd do my R's going round and round like snails because it looked prettier, yet I'd get a slap for it'.[10] Elliott Puckette's paintings of abstract calligraphic writing encapsulate Westwood's episodes of liberty and restraint. What appear to be white lines on dark grounds are, by way of an exquisitely painful process, quite the reverse. Puckette stains white gessoed grounds with washes of ink, then scratches back into the surface with a razor blade (cat. 44). The spirals that appear so swift and free are actually the result of hours of delicate cutting. For Victorian women, the purposes of calligraphy were decorative and circumscribed, but Puckette's determined tracery hurtles beyond elegant epistles and immaculate household ledgers: her lines seem to express the inexpressible. Her drawings are less perversely rendered than her paintings: she applies ink to already inscribed antique papers from India, Italy and Britain (cats. 45, 46, 47). In these cases, Puckette's hand does travel freely with spontaneous and sensual abandon.

*IS*

10  Vivienne Westwood quoted in Marion Hume, 'Portrait of a Former Punk', *Vogue*, September 1994, p. 208.

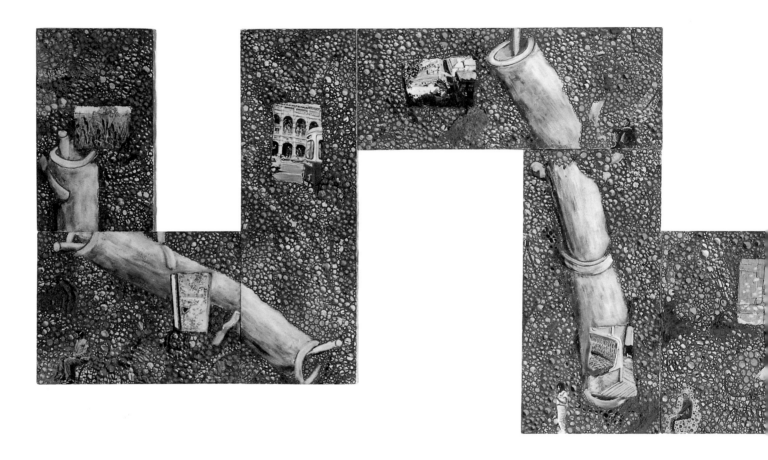

17
**Jeffrey Dennis**
*News from Nowhere (Bends in the River)*, 1991-92

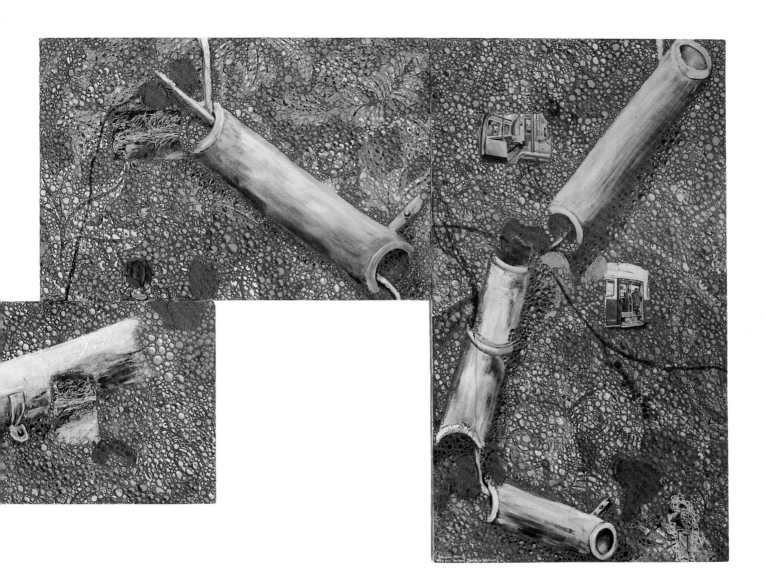

22
**Louise Hopkins**
*Aurora 13*, 1995-96
oil paint on reverse of patterned furnishing fabric
183 x 130 cm

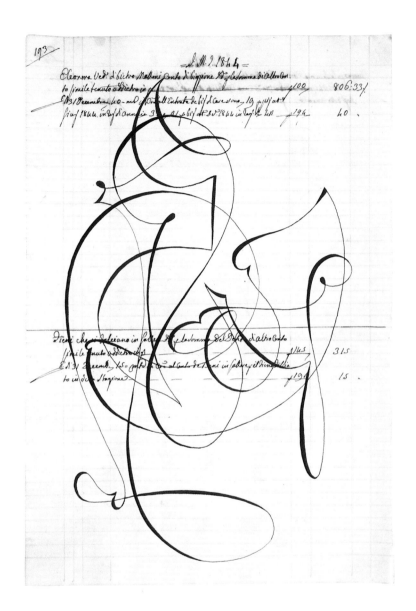

45
**Elliott Puckette**
*Untitled*, 1996

46
**Elliott Puckette**
*Untitled*, 1997

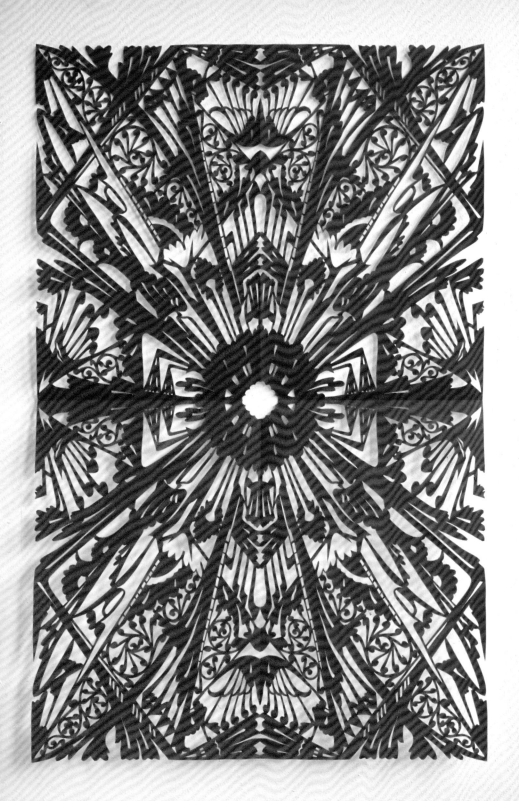

37
**Simon Periton**
*Doily for Christopher Dresser*, 1996

39
**Simon Periton**
*Breathless (Lilac)*, 1998

photography &

One way would be to turn photography in 'on itself' so that a
certain self destruction would occur. Pictures disappearing into the
blackness of which they were formed ending the medium forever.
(Steven Pippin, 1995)[11]

P hotography ranks highly among the significant inventions of the nineteenth century; Queen Victoria and Prince Albert were among its most eminent enthusiasts. (Legend has it that to mask her nervousness on the day that she proposed to him, Victoria talked to Albert about Daguerre s invention.[12]) They commissioned sumptuous albums documenting places of historic, industrial and scenic interest throughout Great Britain. Also, the Victoria and Albert Museum holds the distinction of being the first public institution to collect photography, starting in 1853. Portraits of the Queen herself are famously dour; she is known to have personally disliked the process of having her picture taken. Considering the discomfort wrought by early cameras, whose exposure time required sitters to remaining stationary, as though dead, for minutes, who would not appear a little sombre? However, Victoria s expression belies the spirited sense of curiosity, ingeniousness and delight with which both she and Victorians in general embraced the medium.

To begin with, photography was not simply a means of reproduction distinct from its mechanisms. Early photographers, called operators , were encumbered with equipment, instruments and chemicals. Early photographs were crudely cut from sheets of tin, or impressed under sheets of glass, mounted between the embossed and decorated cardboard pages of albums, or in ornamental frames that resembled the furniture-like apparatus of the

11 Steven Pippin, Pictorial Trouble Shooting , *Discovering the Secrets of . . . Monsieur Pippin*, FRAC Limosine, 1995, p. 52.

12 Photography s inception and the beginning of the Victorian period practically coincide. Victoria ascended the throne in 1837; only two years later, in 1839, Daguerre and Talbot independently announced their inventions.

camera itself. Casting himself as a gentlemanly crackpot, **Steven Pippin** is a contemporary artist whose work returns to this spectacle of photography, attended not only by its implements, but also by a nearly vaudevillian performance. For *The Continued Saga of an Amateur Photographe*r, November 1993 (cats. 40, 41), Pippin transformed a toilet in a train into a pinhole camera. A film documenting the event shows the artist, dressed in a dapper suit and tie, going about his photographic business on board the moving locomotive. He fits an aperture over the bowl, heats the water with an electric coil, adds developer, etc. The resulting images, unfurled from inside the bowl that served as both camera and developer, are panoramas and holes. They encompass the cabin, the photographer, the toilet, along with blurs, blackness, scratches and other deforming abstractions that occurred during the process of their making. As bi-focal indexes, the prints record both camera and event, while remaining dependent on the context of each in order to fully disclose their content. Pippin s work degrades those qualities of photography touted by modernism - its lucidity, objectivity and precision - in favour of a flagrantly subjective vision of the medium looking back on itself and into obscurity.

As the nineteenth century progressed and photography became easier, the number of its practitioners rose. Coincidentally, so did the number of women who considered themselves artists. The great Victorian photographer, Julia Margaret Cameron, who came to photography late in her life, primarily in the hope of earning some money, rued the number of table linens she spoiled spilling silver nitrate. Because it could be done at home and, perhaps more significantly, because it was not then considered to be high art, Victorian women, who were encouraged to dabble, were also free to experiment with photography. Many turned to the most convenient subjects at hand: their children. The work of **Sally Mann** harks back to this history of photography, and to Cameron in particular. Her domestic circle, keenly observed, is the focus of her lens, the presence of which prompts an occasion for play-acting and for acting out roles and fantasies. Cameron photographed her daughters and friends, dressed as characters from medieval legends, sensuously languishing like figures from

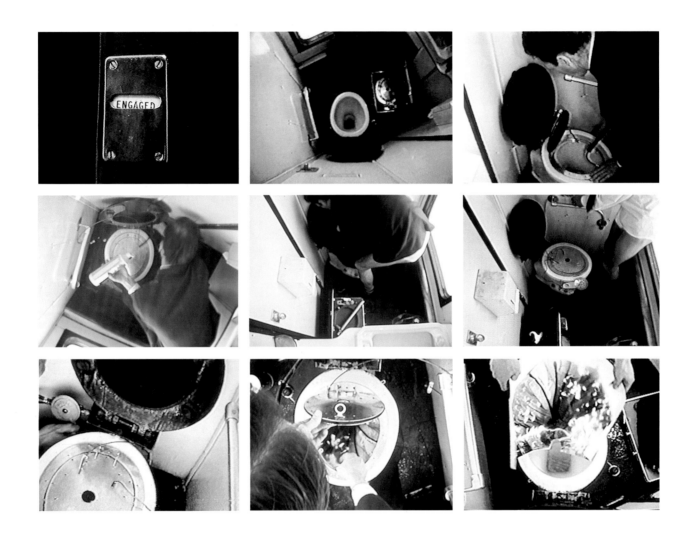

**40**
**Steven Pippin**
*The Continued Saga of an Amateur Photographer,* November 1993
stills from video Hi-8, 22 minutes (detail)
Photo courtesy F.R.A.C. Limousin
© F. Magnoux Collection

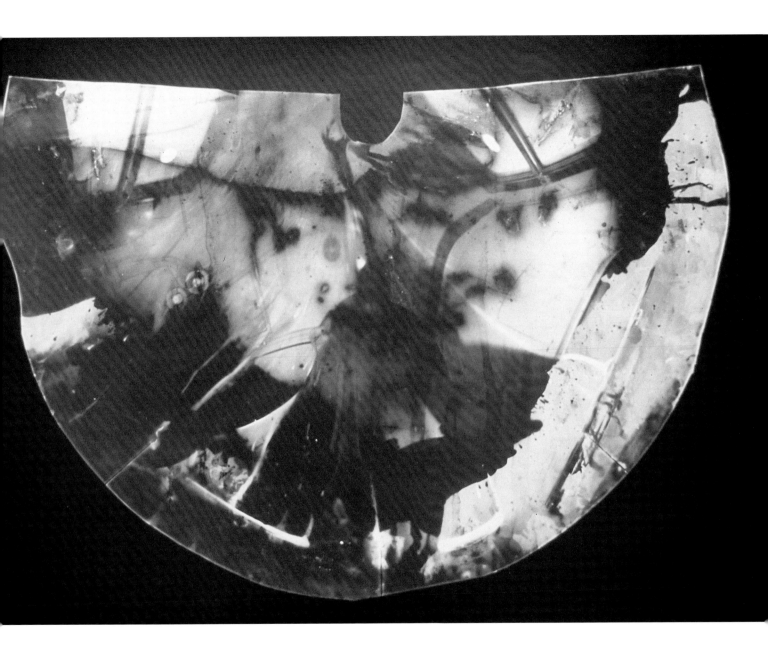

40

**Steven Pippin**
*The Continued Saga of an Amateur Photographer*, November 1993

a Pre-Raphaelite dream. Mann s photographs are less scripted; collectively they depict childhood spent in the paradise of the family s home in a rural setting, inhabited by two daughters and one son, plus anonymous extras, who swim, sunbathe, dress-up, undress, snooze, slouch and perform. The last of these is what gives the pictures their charge: as much as Mann sets the stage for these idyllic and sometimes disturbingly intimate images, her children are vividly playing to, for, and against their mother s voyeurism (cats. 26-30). Mann s images provocatively evoke the duality of tender sentiment and perceptive realism that make Victorian representations of children so compelling. In literature, for example, children are miniature adults, simultaneously innocent and potent beings, as capable of turning social orders upside-down (e.g. Oliver Twist) as they are of creating new worlds (e.g. Alice in Wonderland).

In Victorian times, infant mortality soared. Memorializing the dead was one of commercial photography s first businesses; beyond this was the vogue for spirit photography, which began in America in the wake of the Civil War, and which found keen conviction, in Britain, with the creator of Sherlock Holmes, Sir Arthur Conan Doyle. Death was a booming industry during the nineteenth century; for even the most basic bourgeois funeral, it was common to hire professional mourners, or mutes, and spend on feathers , weepers , elaborate coffins, hearses, grave stones, sculpture and tombs, as well as oceans of bombazine, crape and other mourning paraphenalia.[13] The Victorian preoccupation with death might be compared with our current obsession with sex, and sex and death tragically intersect in the elegiac photography of **Bill Jacobson**. His Interim series refers directly to Victorian aspects of photography (cats. 23, 24). The images show the bodies of young men, posed singly or as

13  Feathermen or feathers walked in front of the coffin waving black ostrich plumes that echoed those on the hearse; weepers were long streamers of black crape that hung from the silk hat of the undertaker.

14  Bill Jacobson, About The Work , unpublished statement issued in conjunction with the artist s exhibition in 1995 at the Julie Saul Gallery, New York.

15  Roland Barthes, Camera Lucida: Reflections on Photography, trans. Richard Howard, Hill & Wang, New York, 1981, p. 96.

16  The artist in an interview with Thomas Kellein, Hiroshi Sugimoto: Time exposed, Kunsthalle Basel, 1995, p. 92. Cf. Ralph Rugoff, Half Dead , Parkett, number 46, 1996, pp. 132-136.

embracing couples; gently faded and blurred, they appear as luminous sculptural presences against indistinct grounds. Jacobson writes that the series draws 'on feelings around the tentativeness and vulnerability of life in the age of AIDS . . . So often friends and lovers are left with only photographs as reminders . . . the prints achieve a slight sepia which suggests flesh while also recalling the tones of early photographs . . . [evoking] ghosts and spirits of a rapidly disappearing segment of the population.'[14]

Death is one of photography's essences, as Roland Barthes has observed. Pondering an 1865 portrait of a condemned man, he writes, 'I read at the same time: this will be and this has been . . . The photograph tells me death in the future . . . whether or not the subject is already dead, every photograph is this catastrophe.'[15] The contemporary photographer **Hiroshi Sugimoto** takes pictures of subjects suspended in a curious state between life and death. Working in series, Sugimoto has photographed empty movie palaces, wax museum tableaux, natural history museum dioramas and the sea. He usually takes his pictures at night, setting his camera up for long exposures that absorb the surrounding darkness and create an image with unnaturally minute detail. His photographs share this quality with daguerreotypes, those black mirrors of early photography in which one's gaze is met by a miniature world, reproduced in negative. Reinforcing the idea of death in photography, by mechanically snatching a moment from the flow of life and bringing it to eternal rest, Sugimoto's animal and portrait subjects are, respectively, stuffed and wax figures, only half-convincing representations of living creatures. His wax Queen Victoria (cat. 54), for example, hovers between upholstery and royalty. This condition seems, from a Victorian viewpoint, well-suited to the photographic pursuit: Sugimoto once told an interviewer that like photography itself, 'Maybe I am already half dead.'[16]

*IS*

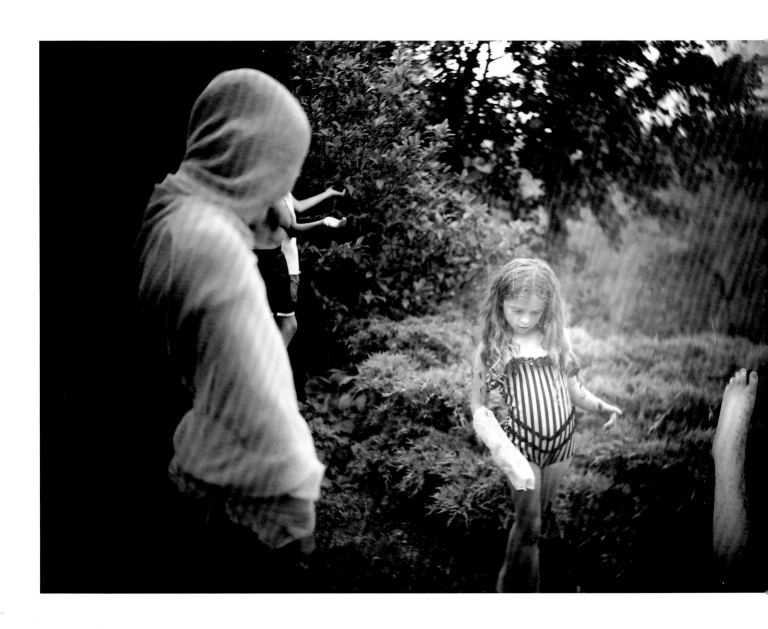

27
**Sally Mann**
*The Last Cracker*, 1991

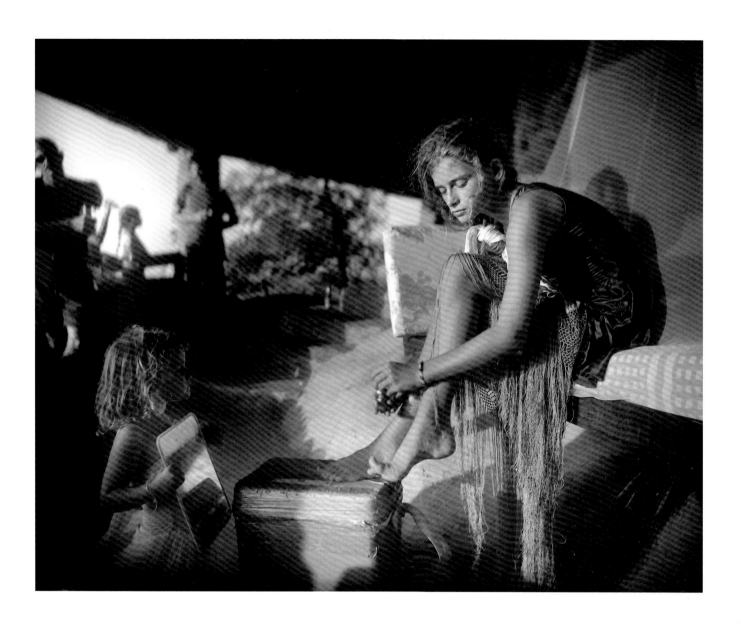

29
**Sally Mann**
*The Virtuous Girl*, 1994

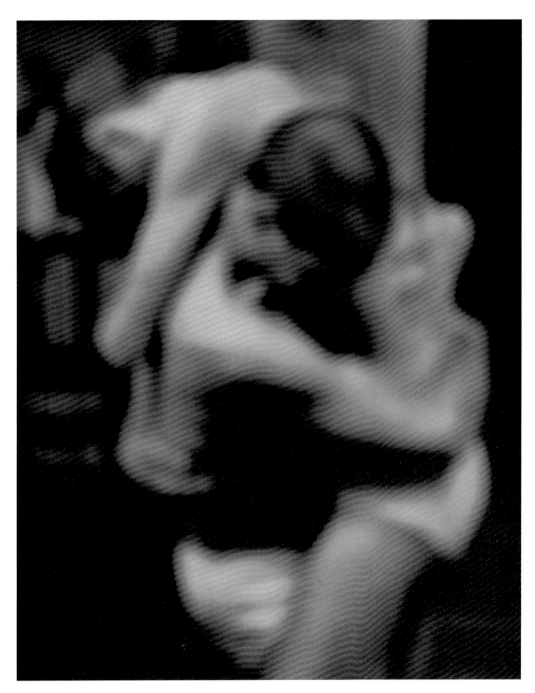

24
**Bill Jacobson**
*Interim Couple #1098*, 1994

23
**Bill Jacobson**
*Interim Portrait #522*, 1993

54
**Hiroshi Sugimoto**
*Queen Victoria* (from *Wax Museums I*), 1994

56
**Hiroshi Sugimoto**
*The St. Albans Poisoner* (from *Wax Museums II*), 1994

# COLLECTING

# & COLONIALISM

From the mantlepiece to the museum, the Victorians were passionate collectors, eager to acquire specimens of the natural world, works of art, anthropological artefacts and bibelots, all with an equal sense of priority. Colonial conquests, new modes of mechanical reproduction (especially photography), steam engines and a powerful belief in Manifest Destiny, made the world smaller and its objects more accessible and desirable. So central was collecting, as both metaphor and impulse, to nineteenth-century culture, that Freud ascribes it a key role in his formulation of the modern psyche and psychoanalysis. Accordingly, the psychoanalytic process entails confronting neurosis by retrieving *things* from the unconscious, that great dark collection of images, thoughts, memories, dreams and fears.[17] And, inasmuch as collecting generally serves as a means of control, of checking time, of thwarting death and of shaping history, the appeal to the Victorians, whose world was changing with industrial speed, is appreciable.

17  cf. Dr. Francis McKee's excellent essay 'Every Creeping Thing: The Anxieties of Collecting', *The Institute of Cultural Anxiety*, Institute of Contemporary Art, London. Freud, as McKee observes, was himself an avid collector of antiquities. McKee writes, 'The close parallels between Freud's material collections of artefacts and his trawl of the unconscious is best described by the poet Hilda Doolittle, recalling the setting in which she was analysed by him: "Thoughts were things, to be collected, analysed, shelved or resolved".'(p. 10).

**Jane Hammond**'s art arises out of a Victorian nexus of collecting and control. Having come to painting during the days of minimal and conceptual art, Hammond, whose disposition was for the pictorial, decided to make some rules for herself. First, she created a lexicon, a collection of 276 images, which she used in various combinations in her subsequent paintings. The earliest of these were titled, inventory style, with numbers cataloguing the images on view. An illustrated atlas provides the stage for the composition of *A Parliament of Refrigerator Magnets*, 1994 (cat. 20); its subjects - from a centaur to a tent - are, like the great nineteenth-century collections, encyclopaedic in scope, culled from many times and places. Wishing for another system of regulation, in 1993 Hammond asked the poet John Ashbery to compose a list of titles for her to paint. *A Parliament of Refrigerator Magnets* is one of the 44 with which she will work until all have been used: the others include 'Long-haired Avatar', 'Prevents Furring', 'Confessions of a Fop', 'Sea of Troubles' and 'The Mush Stage'. Like the lexicon, Hammond claims it is the element of freedom in restraint that she enjoys most about *The John Ashbery Collaboration*: the liberty to do anything within prescribed limitations.

**Joan Nelson**'s landscapes may appear seamless compared with Hammond's painted collages, but they are no less artificially constructed and eclectic in their appropriations. Nelson collects fragments of scenery from a vast array of sources, from Walt Disney

20
**Jane Hammond**
*A Parliament of Refrigerator Magnets*, 1994

21
**Jane Hammond**
*Love You in the Morning*, 1997

35
**Joan Nelson**
*Untitled (After Friedrich Brentel 'Spring')*, 1995

34
**Joan Nelson**
*Untitled (#420)*, 1995

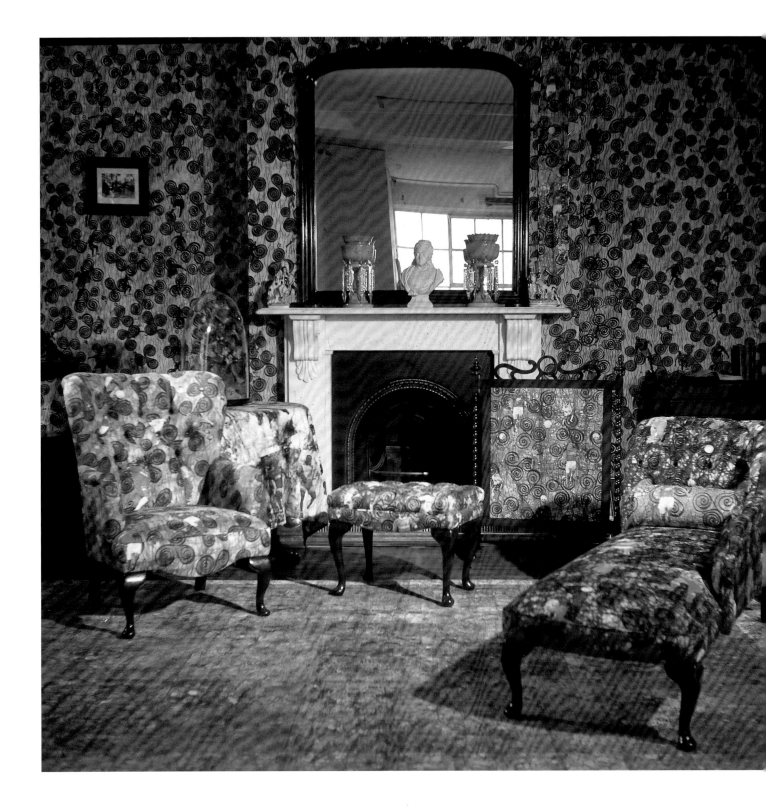

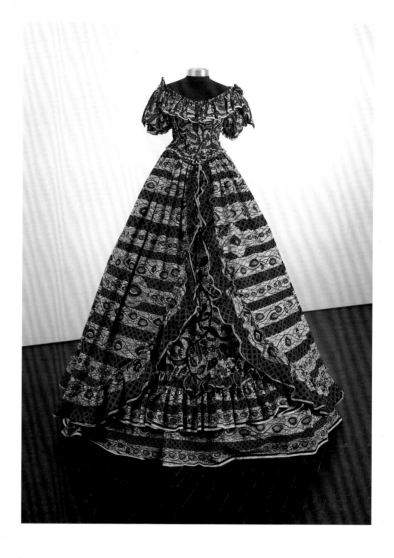

**Yinka Shonibare**
*Victorian Philanthropist's Parlour,* 1996-97
reproduction furniture, fire screen, carpet, African fabric
dimensions vary according to installation
© the artist 1998
Courtesy Stephen Friedman Gallery, London

**Yinka Shonibare**
*Dressing Down*, 1997
wax printed cotton textile, crinolene
display stand: aluminium, plastic, felt
150 x 150 x 175 cm
© the artist 1998
Courtesy Stephen Friedman Gallery, London
Photo: Stephen White

cartoons to European Old Masters, from anonymous snapshots to her own backyard (cats. 32-36). One or several of these are composed into a picture. (The recycling element in Nelson's work brings to mind fellow-painter **Glenn Brown**'s practice of copying existing works in order to assemble a private museum, housed in the imagination.) Nelson's materials are also disparate; they include baby powder, cinnamon and nail polish, along with more conventional pigments. She tends, like Jane Austen, to work in miniature. What Austen wrote of the scope of her novels, is mirrored in Nelson's landscapes: 'the little bit (two inches wide) of Ivory on which I work with so fine a Brush, as produces little effect after much labour.'[18] This lack of concern for spectacular effect enforces an intimacy that seems radical in its own way: modest and acutely observed. Given all that they encompass, Nelson's landscapes are biospheres masquerading as terrariums.

The original plans for the Victoria and Albert Museum included a goliath conservatory structure, the Crystal Palace, erected in the middle of Hyde Park (right over the existing trees) from spandrels of iron and sheets of glass to house the Great Exhibition of 1851. It was the brainchild of Prince Albert and the first of its kind: a world exposition of culture and technology. Based on its tremendous success and profits, a permanent museum was founded to carry on the Exhibition's mission of educating and elevating popular taste, stimulating trade and otherwise marshalling society towards greater production and consumption of quality goods. This became a model for the Metropolitan Museum of Art, New York, and the Birmingham Museum and Art Gallery, along with other major museums started in the wake of the Industrial Revolution. Richard Tangye, of the engineering firm which put up the money for Birmingham's first acquisitions, explained: '. . . our competitors on the continent, in almost every manufacturing town, have access to collections containing the finest examples of art, furnishing an endless variety of style and design.'[19] Museums also displayed pillage and plunder not necessarily intended for emulation, but as signs of subjugation and imperial power. Indeed many ethnographic collections began as random accumulations of the souvenirs, artefacts and other curiosities that traders, soldiers, colonials and missionaries picked up while abroad.

The imperialist prejudices and industrial purviews of nineteenth-century collecting are merged and subverted in the work of **Yinka Shonibare**. Shonibare, a Nigerian who now lives in London, makes sculptural representations of Victorian china and costumes, installed as though in a decorative arts collection or a National Trust property. Such displays typically present an impression of heritage in splendour, but Shonibare foregrounds and dignifies those on whose servitude such grandeur depended for its existence. After scrupulous research, he copied the tea service of a historic house and had pieces inscribed with the names of the servants along with their dates of service. He has clothed mannequins in ornate Victorian garments, complete in every detail of fancywork, pleats and tucks with elaborate skirts and overskirts, bustles, vests and bodices. The only departure from the originals is the fabric: yards and yards of African-style kinte cloth (now industrially produced in Europe) whose patterning and colours unexpectedly enliven the rigid architecture of nineteenth-century dress. For *Secret Victorians*, Shonibare has merged

18  Jane Austen, letter to her nephew
    J. Edward Austen, 16 December 1816,
    quoted in Michael Kerrigan (ed.), *The Wit
    and Wisdom of Jane Austen*, Fourth Estate,
    London, 1996, p. 122.
19  Quoted in the visitor's guide: *Birmingham
    Museum and Art Gallery*, Jarrold Press,
    Great Britain, 1991, p. 1.

male (on the bottom) and female (on the top) fashions to produce an androgynous hybrid of the proper Victorian (cat. 48). The sheer oddity of this figure - a sort of sexualized Pushme-Pullyou - underscores the sense of Europeans as 'others' being regarded from outside their culture in terms of an increasingly global language of representation. (A relatively ambivalent version of the same critical sensation attends many of the Japanese-born Sugimoto's images of Western culture.) In other words, Shonibare's displays have the effect of turning the colonizers, with their bizarre customs, into the subjects of scrutiny worthy of museum display.

Working in elegant silhouette on large-scale installations, **Kara Walker**'s drawings show, in caustic vignettes, master-slave relations in the pre-Civil War American South. As a portrait technique, silhouette was considered a suitable pastime for Victorian ladies, as well as being part of photography's prehistory. At first glance, Walker's tableaux appear to be innocent shadow plays, latterday 'Songs of the South'; but it takes only a quick second look to see that they are much more complex. Take just a few vignettes from *World's Exposition*, 1997 (cat. 57), for example: a piccaninny hangs by a monkey tail from a leafy branch, which she is painting, while defecating freely upon a dancing Josephine Baker in a banana skirt; nearby, a black sculptress in eighteenth-century regalia chops off the head of a statuesque white man, who is sodomizing a black boy. In Walker's caricature, neither blacks nor whites fare especially well, as oppressors swap places with oppressed, and vice versa. No matter how much it is revised or recast, this picture of tumult, of tumbling and tangling elements of a history, is inescapably perverse and cruel. Apparently, racial stereotypes are so ingrained in our culture as to seem hardly dated at all. Casting herself in the fracas, Walker takes a performative role (like Steven Pippin, who plays the amateur photographer), billing herself in one melodramatically long-winded and Victorian title: *Presenting Negro Scenes Drawn Upon My Passage Through the South and Reconfigured for the Benefit of Enlightened Audiences Wherever Such May Be Found, By Myself, Missus K.E.B. Walker, Colored*, 1997. The dark humour that prevails throughout Walker's work recalls something Freud wrote about laughter: 'Humour is not resigned, it is rebellious.'[20]

*IS*

20  For further reading on Freud's writings
    on humour as a prescription for political
    representation, cf. the title essay in
    Jo Anna Isaak, *Feminism & Contemporary
    Art: The Revolutionary Power of Women's
    Laughter*, Routledge, London and
    New York, 1996.

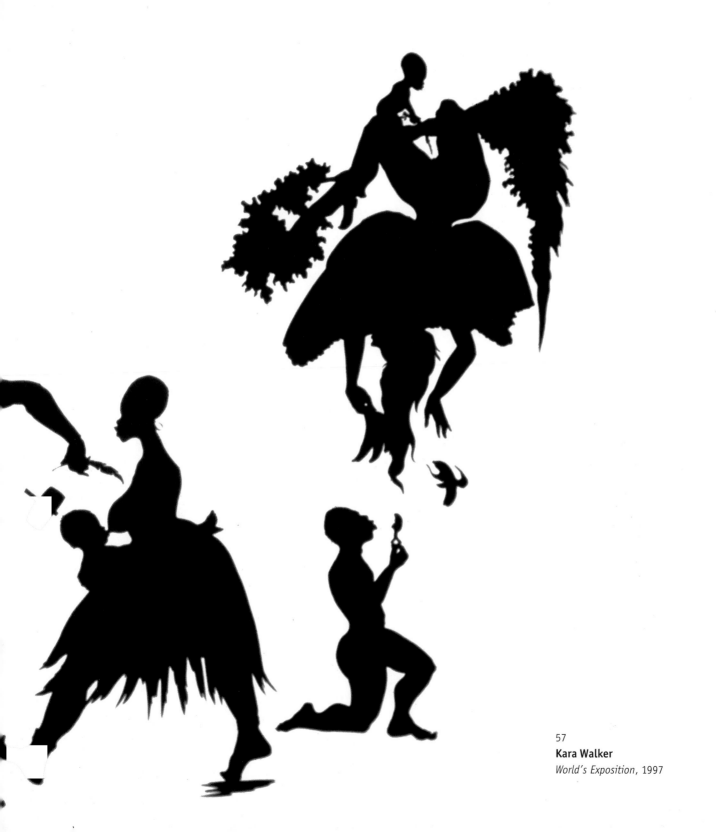

57
**Kara Walker**
*World's Exposition*, 1997

The Victorians' enthusiasm for scientific research often strayed into unlikely areas of study. Composing detailed case histories, Freud used the empirical method to formulate a subject as intangible as his theory of the unconscious. Linking lust to overcrowding in cities, Thomas Malthus, the nineteenth-century 'moral statistician' (as social scientists were then known) proffered mathematical proof to support his view that sexual abstinence was the only cure for overpopulation.[21] With the invention of photography came the empiricist's accomplice: a tool for 'objectively' recording one's findings, among them, the presence of ghosts.

Applying scientific methods to their work, a number of artists in *Secret Victorians* reveal the persistence of some of the defining ideologies of the Victorian era - from positivism and Darwinism to the infatuation with new technology. In her investigations of the body **Helen Chadwick** often turned to science for instruments and inspiration, whether superimposing a tempest of viral cells extracted from her own body across a computer-manipulated photograph of the Pembrokeshire coast, or featuring premature or deformed foetuses from medical museums as the subjects of cameo-like portraits. In the last series before her death, *Unnatural Selection*, 1996, enlarged photographs of fertilized human eggs - actually the pre-implantation embryos from which *in vitro* fertilization takes its name - are presented as gigantic jewels within clear Plexiglas settings. To obtain these images, Chadwick had to engage fully with the medical *modus operandi*, from gaining the consent of the donating couples to mastering the difficult technique of orally manipulating this microscopic matter through a glass pipette. Darwin's legacy, she reminds us, has never been stronger than in recent feats of assisted fertility and genetic engineering. But *Unnatural Selection* also represents the degree to which science has penetrated our private lives; it is a force that cures but also controls.

Chadwick's memorials to these stilled lives draw inspiration from Victorian funereal customs, wherein relics of the dead, such as braided hair, were encased in glass lockets and worn by mourners. The tangled strands of cells in *Opal*, 1996 (cat. 11), for example, even resemble hair. Chadwick's works seem to suggest a relationship between the prevalence of infant death in the nineteenth century and of infertility today.

21  Peter Gay, *The Cultivation of Hatred*, Fontana Press, London, 1995, p. 40.

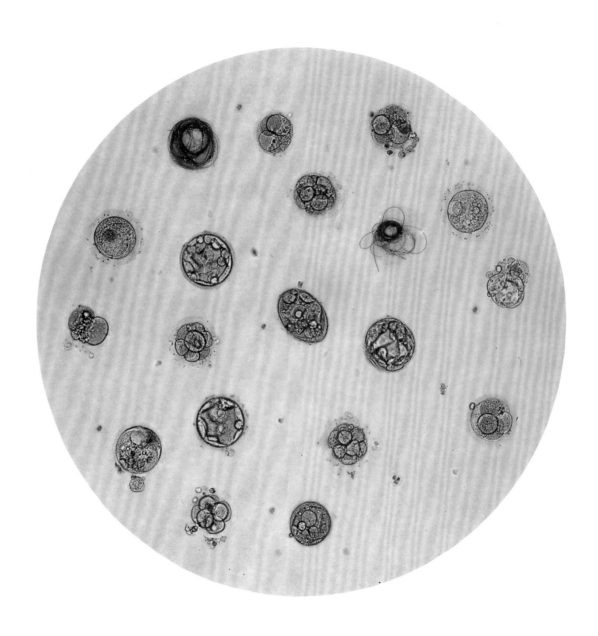

11
**Helen Chadwick**
*Opal*, 1996

9
**Helen Chadwick**
*Cyclops Cameo*, 1995

*Monstrance*, 1996 (cat. 10) is an oval brooch as large as a looking-glass, seemingly attached to the wall by its plastic pin; a column of silvery cellular constellations glows against the blue-grey ground. The title refers to another type of reliquary, that of the vessel in which the host is presented to worshippers in Christian ritual. In this work, art's facsimile of nature merges with science's simulation of reproduction and the symbolic manifestation of the body of Christ in religion. From the aesthetic eye of the artist to the scrutiny of the empiricist, the authority of the visual sense is also interdisciplinary, and its extensions in the camera, the microscope, the sonagram and the telescope remind us of the human eye's insistence on seeing all, everywhere. This panoptical urge gained force in the nineteenth century, as Michel Foucault illustrates in his analysis of the architectural design of penitentiaries.[22]

The heady imagery of modern science seems close to traditional religious art. Although the swirling cloudscape in **Glenn Brown**'s *Jesus; The Living Dead (after Adolf Schaller)*, 1997-98, (cat. 5) offers a God's-eye view of the heavens reminiscent of nineteenth-century apocalyptic painting, its actual source is a scientific rendering of a planetary surface by the American commercial artist credited in the title. Brown's billboard-size version, copied from a clipped illustration according to his usual working method, embellishes the level of detail as well as the colour in the original. This overzealous concern with detail - his paintings can be mistaken for photographic reproductions - together with a prismatic, sickly-sweet palette led by lavender and red brings to mind Pre-Raphaelite paintings, the work of Edward Burne-Jones in particular.

22  Michel Foucault, *Discipline and Punish*: *Birth of the Prison*, Penguin Books, London, 1991.

There is no doubt about **Laura Stein**'s engagement with science. Her work involves horticultural experiments in aberrant grafting and gardening. Tomatoes, for example, are forced to grow within polyurethane moulds shaped like cartoon characters - Sylvester the Cat, Snoopy, etc. - and turn out surprisingly full-featured. In colour photographs documenting the tomatoes' growth- sumptuously lit in the manner of a food advertisement - the cute, smiling faces parody the redder, rounder hot-house variety (cat. 51). Yet these seemingly decapitated heads also bear spots of rot and malformed areas, failing as both faces and fruit. These works offer a critique of the collusion between science and industry in attempting to outdo nature, but at the same time revel in its artistic possibilities. Stein also makes living sculptures by grafting together disparate plants. In her most subtle splicing, the collaged hand-tinted and colour-xeroxed parts of different botanical prints coalesce into elegantly unnatural species (cat. 50). These two- and three-dimensional hybrids flout empiricism's rigid schemes of classification in favour of florid creativity.

Stein's horticultural handiwork recalls the domestic hobbies, ranging from needlepoint to taxidermy, described in a plethora of nineteenth-century 'how-to' books and women's journals. This science-mindedness in the female domain also exerts itself in ladies' watercolouring manuals that furnish the colour codes for **Suzanne Bocanegra**'s assemblages. In such works as *Table of Colours for Sunsets, All Parts of Sky*, 1995 (cat. 2), little painted swatches bearing a recommended red, yellow or orange tag each object - bits of string and rag, quilt squares, a jar lid - displayed in a shelf-like arrangement. By using these formulae to order household scraps, Bocanegra bolsters them with imaginative play that the nineteenth-century instructions would otherwise constrain.

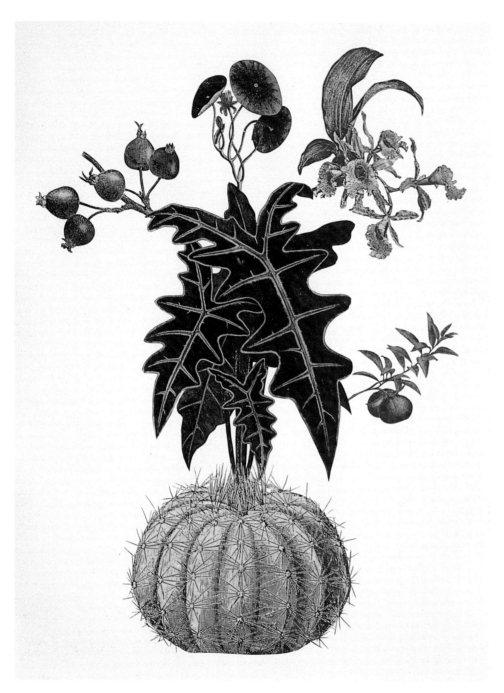

50
**Laura Stein**
*Graft Study # 12*, 1994

51
**Laura Stein**
*Filled*, 1996

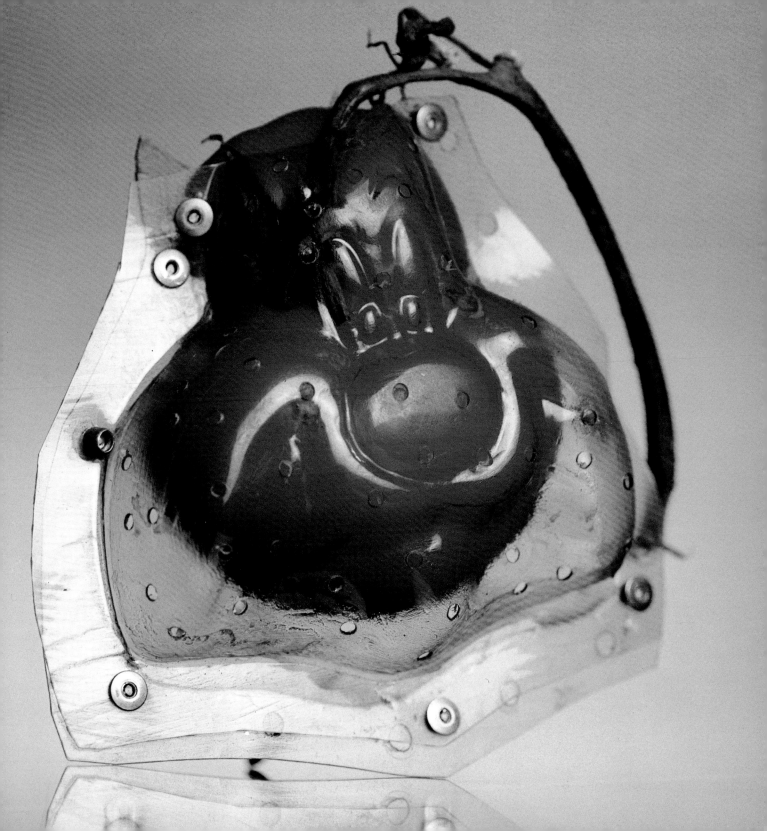

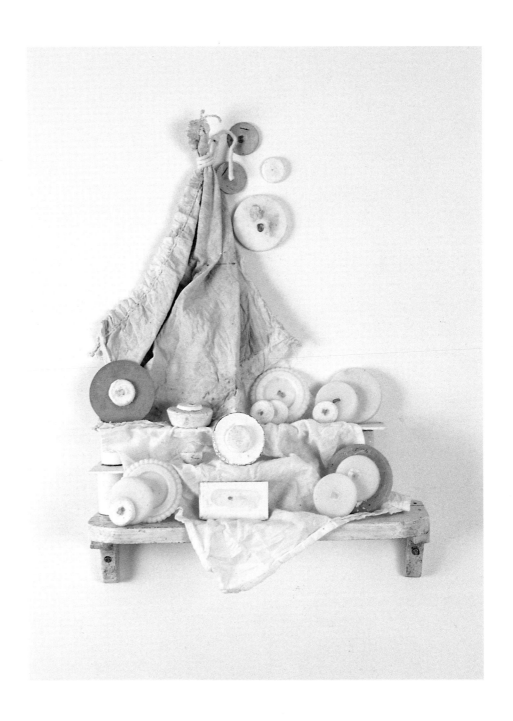

3
**Suzanne Bocanegra**
*Table of Colours for Sunsets and Sunrise Clouds if Deep Orange*, 1995

2
**Suzanne Bocanegra**
*Table of Colours for Sunsets, All Parts of Sky*, 1995

The Victorian zeal for orderliness and solutions overflowed into other areas of life, giving rise to such illogical inventions as air-tight terrariums and a heavy mahogany 'life-saving chair' for those stranded at sea. While these were inadvertent failures, **Steven Pippin**'s handmade machines purposely negate the nature of the technologies they utilize. Record players are rendered inaudible; television regresses to black and white photography - refusing in either case to entertain or inform, Pippin plays out these technical stunts in Buckminster Fulleresque structures of his own design. Technological advances, such works suggest, have their setbacks: lassitude, dehumanization, banality. The hand-fabricated, self-defeating inventions of this former engineer nonetheless embrace the nineteenth-century ethos of industry-for-industry's sake.

Pippin also transforms train toilets, laundromats and, most mockingly, automatic photobooths into camera obscura, turning modern conveniences into inconvenient, antiquated equipment. Conversely, **Mat Collishaw** wires up antique apparatuses and furniture with new technology and/or incongruously contemporary subject matter. The viewfinder of an old large-format wooden camera atop a quaint curvilinear stand offers an image of an idyllic landscape with a waterfall which appears in moving colour. *Soliciting a Reward*, 1994 (cat. 15) is modelled on Eadweard Muybridge's praxinoscope, an instrument devised by the early photographer for presenting his 'animal locomotion' studies as the first screen-projected moving pictures. Collishaw's re-creation features not the galloping horses and vaulting gymnasts that were the energetic subjects of the nineteenth-century precursor, but a middle-aged accordionist busking by the escalator at a tube station. The mechanics of animation are lost on this figure who is almost motionless but for the slight sway of his instrument. Although staged at a site of mass transit and in motion, ultimately the work is not about movement and progress but about stasis and confinement. The escalator looming behind the figure emphasizes his lowly position. Soft strains of this old timer's music croon from the tape recorder unceremoniously placed on the floor beside the cast iron base - a forlorn sound that brings to mind old dance halls.

The title *Soliciting a Reward* refers to experimental psychology - the world of Pavlov's salivating dogs and Harlow's love-starved monkeys - and suggests that human life is also at the mercy of some larger social system. In this as in other works featuring prostitutes, bums and teenage drug addicts, Collishaw points to the underbelly of modern society. The industrial revolution created cities, cures, and conveniences but with them came crime, overcrowding and disease.

A fascination with criminality and deviance has become one of modern society's greatest entertainments. Selected scenes from Madame Tussaud's Chamber of Horrors, surveying 200 years of crime and punishment, form the subjects of **Hiroshi Sugimoto**'s 1994 series, *Wax Museum II*. From *The Brides in the Bath Murderer*, 1994 (cat. 55) to *The St. Albans Poisoner*, 1994 (cat. 56) seen standing outside his prison cell, Sugimoto's catalogue of crime points to the museum and the prison as institutional formulations of nineteenth-century empiricism. Murder was an extreme reaction to nineteenth-century social upheaval and repression; more common psychic outlets were hysteria (no control) and obsessive-compulsive disorders (too much control) - the classic neurotic disorders of Freudian theory. The former malady is the subject of **Douglas Gordon**'s black and white video, *Trigger Finger*, 1994 (cat. 18), featuring medical footage of a First World War victim's hysterical paralysis. An isolated hand spastically contorts itself into the shape of a gun, repeatedly pointing and firing. The Victorian aspiration to master the world degenerated into many forms of madness - dark deeds and ways that stir the imagination.

*MF*

# CONCLUSION

Perhaps one of the most intriguing paradoxes of *Secret Victorians* is how contemporary the Victorian now appears. The art in *Secret Victorians* is not retrograde, but a vital part of today's culture. In a curious way, today's Victorian is a radical, who ventures into territory designated off-limits. We have come to expect cool style and adolescent high jinks from the current avant-garde, while the political edginess of the florid, narrative, detail-obsessed, discreet, erotic, inventive, imaginative, melancholic and highly-crafted comes as a surprise. By revealing aspects of Victorian sensibility through contemporary art, *Secret Victorians* asks whether modernism is actually a break from or a continuation of nineteenth-century precepts. In a recent essay observing the 150th anniversary of the Communist Manifesto, Steven Marcus painted a picture of continuity between the past and the present: 'Today, in the deepening twilight of the 20th century . . . one grand matter that appears not to have passed into the quaint status of being post-itself is bourgeois society.'[23] Perhaps then we are all secret Victorians.

23 'Whether it is regarded as capitalist democracy, as civil society, as the welfare state in transition or as the modern social contract, bourgeois society . . . remains alive and well - which means of course, as it always has, that it is in a hell of a state.' Steven Marcus, 'Marx's Masterpiece at 150', *The New York Times Book Review*, April 26, 1998, p. 39.

*MF/IS*

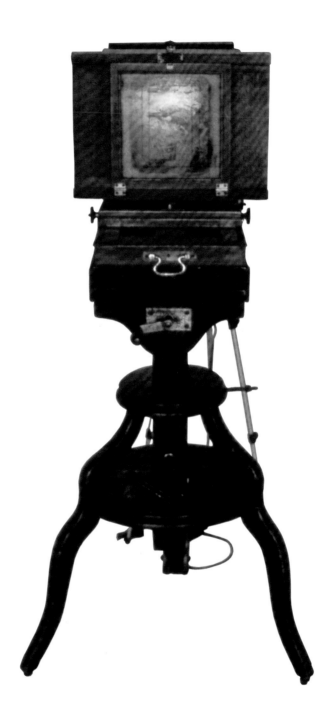

16
**Mat Collishaw**
*Untitled (Babbling Brook)*, 1995

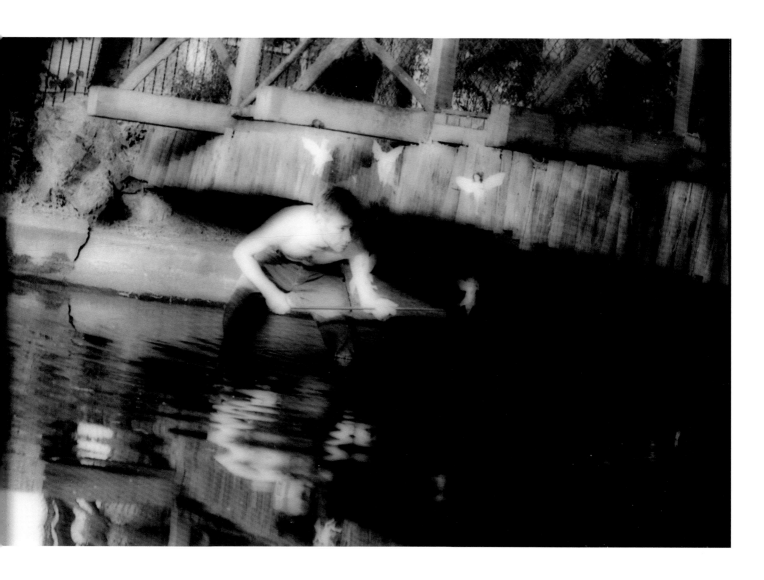

12
**Mat Collishaw**
*Catching Fairies*, 1994

18
**Douglas Gordon**
*Trigger Finger*, 1994

19
**Douglas Gordon**
*Monster*, 1997

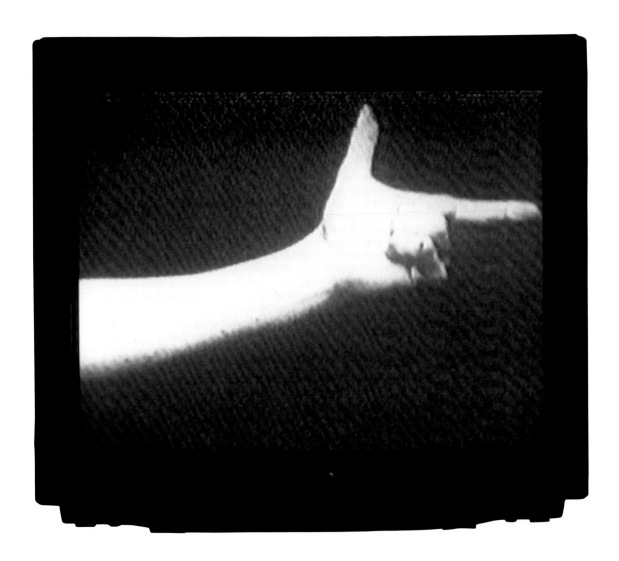

# Biographies

## Suzanne Bocanegra

Born in Houston, Texas, USA, 1957
Lives and works in New York

**Selected Solo Exhibitions**

1993 Queens Museum, Bulova Center,
New York, USA
California Center for the Arts, Escondido,
USA
1992 SKEP, New York, USA
1990 Victoria Munroe Gallery, New York, USA

**Selected Group Exhibitions since 1992**

1997 Muhlenburg College, Martin Art Gallery,
Allentown, USA
1996 *Place*, E.S.Van Dam, New York, USA
1995 *Project Exhibit*, Maryland Institute of the
Arts, Baltimore, USA
*In Three Dimensions*, Newhouse Center for
Contemporary Art, Snug Harbor Cultural
Center, New York, USA
1993 *Times*, Anderson O'Day Gallery, London,
England
1992 *Material Revisions*, Brattleboro Museum,
Brattleboro, USA

## Glenn Brown

Born in Northumberland, England, 1966
Lives and works in London

**Selected Solo Exhibitions**

1998 Patrick Painter inc., Los Angeles, USA
1997 Galerie Ghislaine Hussenot, Paris, France
1995 Karsten Schubert Gallery, London, England

**Selected Group Exhibitions since 1995**

1997 *Sensation*, Royal Academy of Arts, London,
England
1996 *About Vision, New British Painting in the 1990s*,
Museum of Modern Art, Oxford; toured in the UK
*The Jerwood Painting Prize*, Letherby Galleries,
Central Saint Martin's College, London, England
*Ace!: Arts Council Collection new purchases*,
organised by the Hayward Gallery, London,
England; toured in the UK
*Brilliant*, New Art From London, Contemporary Art
Museum, Houston, Texas, USA
1995 *Young British Artists V*, Saatchi Collection,
London, England

## Saint Clair Cemin

Born in Cruz Alta, Brazil, 1951
Lives and works in New York

**Selected Solo Exhibitions since 1995**

1998 *Man Woman Tree Hand Boat House Car Golem*,
Galarie Lars Bohman, Stockholm, Sweden
1997 Robert Miller Gallery, New York, USA
1996 California Centre for the Arts Museum,
Escondido, California, USA
1995 Gian Ferrari Arte Contemporanea, Milan, Italy

**Selected Group Exhibitions since 1994**

1998 *Decorative Strategies*, Centre for Curatorial
Studies, Bard College, Annandale-on-Hudson,
New York, USA
*Defining Structures*, LaSalle Gallery at Nations
Bank Plaza, Charlotte, USA
1997 *Objectivity: International Objects of Subjectivity*,
Contemporary Art Centre of Virginia, Virginia Beach,
USA
1994 Sao Paulo Bienial, Brazil

**Helen Chadwick**

1953-1996, London, England
Works held in private and public collections
in the UK, Europe and the USA

**Selected Solo Exhibitions since 1994**

1997    *Retrospective*, Museum of Modern Art,
Tel Aviv, Israel

1995/6  *Bad Blooms*, Museum of Modern Art,
New York, USA

1994    *Poesis*, Salzburger Kunstverein, Salzburg;
Kunsthaus Glarus, Switzerland
*Flesh and Flower*, Zelda Cheatle Gallery,
London, England
*Effluvia*, Museum Folkwang, Essen, Germany;
Fundacio La Caixa Barcelona, Spain;
Serpentine Gallery, London, England

**Selected Group Exhibitions since 1995**

1998    Toyota Municipal Museum of Art, Japan

1997    *The Quick and the Dead*, National Touring
Exhibition, organised by the Hayward
Gallery, London, England; toured in the
UK and to Geneva, Switzerland

1995    *Féminin - Masculin, les Sexes de l'Art*,
Centre Georges Pompidou, Paris, France

**Mat Collishaw**

Born in Nottingham, England, 1966
Lives and works in London

**Selected Solo Exhibitions since 1995**

1998    Bloom Gallery, Amsterdam, Netherlands

1997    *Duty Free Spirits*, Lisson Gallery, London,
England
*Ideal Boys*, Ridinghouse Editions, London,
England; Gallerie Raucci/Santamaria,
Naples, Italy

1995    Camden Arts Centre, London, England

**Selected Group Exhibitions since 1997**

1998-99 *Exhibition of Contemporary British Art*,
Japanese Museum Tour

1998    *Exterminating Angel*, Galerie Ghislaine
Hussenot, Paris, France
*London Calling*, British School in Rome,
Italy

1997    *Pictura Britannica: Art from Britain*,
Museum of Contemporary Art, Sydney,
Australia
*Sensation*, Royal Academy of Arts, London,
England
*London Live,* Kunstmuseum Wolfsburg,
Germany
*Urban Legends*, Staatliche Kunsthalle,
Baden Baden, Germany

**Jeffrey Dennis**

Born in Colchester, England, 1958
Lives and works in London

**Selected Solo Exhibitions**

1994    Anderson O'Day Gallery, London, England

1993    Salvatore Ala Gallery, New York,
USA
Orchard Gallery, Derry, Northern
Ireland

**Selected Group Exhibitions since 1995**

1998    *La Collection*, Foundation Cartier pour l'art
contemporain, Paris, France

1997    *John Moores Exhibition 20*, Walker Art
Gallery, Liverpool
*Drawing Distinctions: Twentieth-century
Drawings & Watercolours from the British
Council Collection*, Berkeley University,
California; Phoenix Museum, Arizona, USA

1996    *New Voices: Work from the British Council
Collection*, touring exhibition

1995    *Home and Away: Internationalism and
British Art 1900-1990*, Tate Gallery
Liverpool, England

## Douglas Gordon

Born in Glasgow, Scotland, 1966
Lives and works in Glasgow

1998    awarded The Hugo Boss Prize by the
Guggenheim Museum
1997    awarded Premio 2000 at the Venice Biennale
1996    awarded the Turner Prize

### Selected Solo Exhibitions since 1996

1997    *5 Year Drive-By*, Kunstverein, Hannover, Germany
*Douglas Gordon*, Biennale de Lyon, France
1996    *The Turner Prize 1996*, Tate Gallery,
London, England
*24 Hour Psycho*, Academie der bidende
Künste, Vienna, Austria

### Selected Group Exhibitions since 1996

1997    *Past, Present, Future*, Venice Biennale, Italy
*Gothic*, ICA, Boston, USA
1996    10th Sydney Biennale, Sydney, Australia
*Spellbound*, Hayward Gallery, London,
England
*Traffic,* CAPC Musee d'Art Contemporain,
Bordeaux, France

## Jane Hammond

Born in Bridgeport, Connecticut, USA, 1950
Lives and works in New York

### Selected Solo Exhibitions

1998    David Beitzal Gallery, New York, USA
Zolla/Lieberman Gallery, Chicago, USA
1997    Luring Augustine, New York, USA
Greg Kucera Gallery, Seattle, USA

### Selected Group Exhibitions since 1997

1998    *Preserving the Past, Securing The Future*,
National Museum of Women in the Arts,
Washington DC, USA
Masters of the Masters, Butler Institute of
American Art, Youngstown, USA
1997    *Proof Positive: 40 Years of Contemporary
American Printmaking at ULAE 1957-1997*,
organised by the Corcoran Gallery of Art,
Washington DC; toured in USA and
Japan

## Louise Hopkins

Born in Glasgow, Scotland, 1965
Lives and works in Glasgow

### Selected Solo Exhibitions since 1996

1997    Galerie Isabella Kacprzak, Berlin, Germany
Art Connexion, Lille, France
1996    33 Great Sutton Street, London, England
Tramway, Glasgow, Scotland

### Selected Group Exhibitions since 1995

1998    *Nettwerk - Glasgow*, Museum of Contemporary Art,
Oslo, Norway
1997    *Pictura Britannica*: *Art from Britain*, Museum of
Contemporary Art, Sydney, Australia
*Jerwood Painting Prize*, Letherby Galleries,
London, England
*Lemonade*, 33 Great Sutton Street, London, England
*Loaded*, Ikon Gallery, Birmingham, England
*Glasgow*, Kunsthalle Bern, Switzerland
1996    *New Contemporaries*, Tate Gallery Liverpool;
Camden Arts Centre, London, England
1995    *The Persistence of Painting*, CCA, Glasgow, Scotland

## Bill Jacobson

Born in Norwich, Connecticut, USA
Lives and works in New York

### Selected Solo Exhibitions since 1997

1998    Rupertinum Museum, Salzburg, Austria
Julie Saul Gallery, New York, USA
1997    Galerie H.S. Steinek, Vienna, Austria
Shoshana Wayne Gallery, Santa Monica, USA

### Selected Group Exhibitions since 1997

1998    *Versus 2000*, Museion (Museo d'Arte
Modern), Bolzano, Italy
1997    *Water*, Pace Wildenstein MacGill, New York, USA
*Brooklyn, NY, USA*, Bonni Benrubi Gallery,
New York, USA
*Oceans and Galaxies*: *Traditional Pathways to
the Infinite*, Karen McCready Fine Art,
New York, USA
*Fracturing the Gaze*, Lawing Gallery, Houston, USA
*The Portrait As Object/The Figure As Ground*,
Howard Yezerski Gallery, Boston, USA
*Disappeared*, Randolph Street Gallery, Chicago, USA

Sally Mann

Born in Lexington, Virginia, USA, 1951

**Selected Solo Exhibitions since 1997**

1998  *Still Time*, PhotoEspaña '98, Madrid, Spain

1997  *Sally Mann: Mother Land*, Edwynn Houk Gallery, New York; Gargosian Gallery, Los Angeles, USA
*Sally Mann: Recent Work*, Photo Gallery International, Tokyo, Japan

**Selected Group Exhibitions since 1996**

1998  *Waterproof, EXPO'98*, Centro Cultural de Belém, Lisbon, Portugal
*C'est la Vie*, Centre d'Art Contemporain, Brussels, Belgium

1996  *From My Window*, Libreria Photo Galeria Railowsky, Valencia, Spain
*Picturing the South*, High Museum, Atlanta, USA

Joan Nelson

Born in Torrance, California, USA, 1958
Lives and works in New York

**Selected Solo Exhibitions**

1998  *Paintings on Paper*, Robert Miller Gallery, New York, USA

1997  *Paintings Over Prints*, CIRRUS, Los Angeles, USA

1996  The Nave Museum, Victoria, USA

**Selected Group Exhibitions since 1997**

1997  *At The Threshold of the Visible: Miniscule and Small Scale Art, 1964-1996*, Independent Curators Incorporated, New York, USA; toured in Canada and USA
*Landscape: The Pastoral to the Urban*, Centre for Curatorial Studies, Bard College, Annandale-on-Hudson, New York, USA
*Rediscovering The Landscape of the Americas*, Gerald Peters Gallery, Santa Fe; toured in USA

Simon Periton

Born in Faversham, England, 1964
Lives and works in London

**Selected Solo Exhibitions**

1997  *Dandeliceum*, Sadie Coles HQ, London, England

1994  *Strange Spectacle*, Gallerie 217, Sportsverbande, Frankfurt, Germany

**Selected Group Shows since 1996**

1998  *Inbreeder*, Collective Gallery, Edinburgh, Scotland
*Lovecraft*, (CCA Glasgow 1997), South London Gallery, London, England

1997  *Supastore*, Cornerhouse, Manchester, England
*Fish and Chips, Diverse Works*, Houston, Texas, USA
*Victoria*, Laurent Delaye Gallery, London, England
*Imprint 93*, Norwich Gallery, Norwich, England
*B.o.n.g.o.*, Bricks and Kicks, Vienna, Austria

1996  *Popocultural*, South London Gallery, London, England
*21 days of Darkness*, Transmission, Glasgow, Scotland
*Co-operators, (Hope)*, Southampton City Art Gallery, England

Steven Pippin

Born in Redhill, England, 1960
Lives and works in London

**Selected Solo Exhibitions since 1995**

1998  *MOMA*, San Francisco, USA

1997  *Terrestrial T.V.*, Gavin Brown's Enterprise, New York, USA

1995  *Negative Perspective*, Ujazdowskie Castle, Warsaw, Poland
*Study in Time and Motion*, F.R.A.C. Limousin, Limoges, France

**Selected Group Exhibitions since 1996**

1997  *Sites of the Visual*, Art Gallery of Windsor, Ontario, Canada
*Material Culture: The Object in British Art of the 1980s and '90s*, Hayward Gallery, London, England

*Antechamber*, Whitechapel Art Gallery,
London, England
*Campo 6: The Spiral Village*, Bonnefanten
Museum, Maastrict, Netherlands
1996    *Life/Live*, ARC, Paris, France
*Do It*, Vienna, Austria

## Lari Pittman

Born in Glendale, California, USA, 1952
Lives and works in Los Angeles

**Selected Solo Exhibitions since 1998**

1998    *Once a Noun, Now a Verb,* Regen Projects,
Los Angeles, USA
*Lari Pittman*, Cornerhouse, Manchester,
England; touring in the UK and Switzerland

**Selected Group Exhibitions since 1997**

1997    *American Stories*: *Amidst Displacement and
Transformation*, Setagaya Art Museum,
Tokoyo, Japan; toured in Japan
*Documenta X*, Documenta und Fredericum,
Kassel, Germany
*Sunshine and Noir*: *Art in LA 1960-1997*,
Louisiana Museum, Humlebaek, Denmark;
toured in Europe and the USA
*1997 Whitney Biennial Exhibition*, The
Whitney Museum of American Art,
New York, USA

## Elliott Puckette

Born in Lexington, Kentucky, USA, 1967
Lives and works in New York

**Selected Solo Exhibitions since 1996**

1998    Paul Kasmin Gallery, New York, USA
1996    Frith Street Gallery, London, England

**Selected Group Exhibitions since 1992:**

1995    *Silhouettes* (with Christopher Bucklow and
Adam Fuss), Paul Kasmin Gallery, New York, USA
*Essence and Persuasion: The Power of Black
and White*, Anderson Gallery, Buffalo,
New York, USA
1993    *Dirty Ornament*, The Rotunda Gallery, Brooklyn,
New York, USA
*Works on Paper*, Paul Kasmin Gallery, New York,
USA
1992    *Group Show*, Tri Gallery, Los Angeles, USA
*Group Show*, Four Walls, New York, USA

## Yinka Shonibare

Born in London, England, 1962
Lives and works in London

**Selected Solo Exhibitions since 1995**

1997    Stephen Friedman Gallery, London, England
*Present Tense*, Art Gallery of Ontario,
Toronto, Canada
1995    *Sun, Sea and Sand*, BAC Gallery, London, England

**Selected Group Exhibitions since 1996**

1998    *Crossings*, National Gallery of Canada
*Liberating Tradition*, Centre for
Curatorial Studies, Bard College,
Annandale-on-Hudson, New York, USA
1997    *Sensation*, Royal Academy of Arts,
London, England
Johannesburg Biennale, South Africa
*Pictura Britannica: Art from Britian*, Museum of
Contemporary Art, Sydney, Australia
1996    *Imagined Communities*, National
Touring Exhibition, organised by
the Hayward Gallery, London, England;
toured in the UK
*Inclusion:Exclusion*, Steirischer
Herbst, Graz, Austria
10th Biennale of Sydney, Australia

Laura Stein

Born in East Patchogue, New York, USA, 1964
Lives and works in New York

**Selected Solo Exhibitions**

1997 *On The Inside*, School of the Museum of Fine
Arts, Boston, USA

1996 *Frankfurt, a Story, and a Song*, Frankfurt,
Germany

1995 *Animal-vegetable*, Basilico Fine Arts,
New York, USA

**Selected Group Exhibitions since 1995**

1998 *Where: Allegory of Site in Contemporary Art*,
Whitney Museum, Champion Branch,
Stamford, USA
*Pop Surrealism*, Aldrich Museum, USA

1996 *The Lie of the Land*, University Art Museum,
University of California, Santa Barbara, USA
*Perfect World*, University at Buffalo Art
Gallery, USA

1995 *Stoppage*, CCC, Tours, France

Hiroshi Sugimoto

Born in Tokyo, Japan, 1948
Lives and works in New York

**Selected Solo Exhibitions since 1997**

1998 Michael Hue-Williams Fine Art, London,
England
The Japan Foundation, Istituto Giapponese
di Cultura in Rome, Rome, Italy
La Caixa, Madrid, Spain
*EXPO'98*, Centro Cultural de Belém,
Lisbon, Portugal

1997 Sonnabend Gallery, New York, USA
*Hall of Thirty Three Bays*, The Sainsbury
Centre, University of East Anglia,
Norwich, England

**Selected Group Exhibitions since 1998**

1998 *Terra Incognita*, Neues Museum Weserburg,
Bremen, Germany
*At the End of the Century: One Hundred
Years of Architecture*, touring in the
Americas, Europe and Japan
10th Biennale of Sydney, Australia

Kara Walker

Born in Stockton, California, USA, 1969
Lives and works in Rhode Island

**Selected Solo Exhibitions**

1998 *Kara Walker*, Wooster Gardens, New York, USA

1997 *Upon My Many Masters - An outline*,
San Francisco Museum of Modern
Art, California, USA

1995 *Look Away! Look Away! Look Away!*,
Centre for Curatorial Studies, Bard
College, Annandale-on-Hudson,
New York, USA

**Selected Group Exhibitions since 1996**

1998 *Arturo Herrera and Kara Walker*, Stephen
Friedman Gallery, London, England

1997 *Whitney Biennial*, The Whitney Museum of
American Art, New York, USA
*no place (like home)*, Walker Art Center,
Minneapolis, USA

1996 *New Histories*, Institute of Contemporary
Art, Boston, USA
*Conceal/Reveal*, Site Santa Fe, Santa Fe, USA

# List of Works

1
**Suzanne Bocanegra**
*Table of Colours for Cattle*, If Bay, 1995
wax, fabric, plaster, watercolour, paper on wood shelf
175.2 x 22.8 x 31.7 cm
Collection of the artist

2
**Suzanne Bocanegra**
*Table of Colours for Sunsets, All Parts of Sky*, 1995
wax, paper, plaster, watercolour, fabric on wood shelf
60.9 x 45.7 x 15.2 cm
© the artist 1995
Collection of the artist

3
**Suzanne Bocanegra**
*Table of Colours for Sunsets and Sunrise Clouds if Deep Orange*,
1995
fabric, paper, wax, watercolour on wood shelf
66.5 x 58.5 x 27.9 cm
© the artist 1995
Collection of the artist

4
**Glenn Brown**
*Unknown Pleasures (painting for Ian Curtis) after Chris Foss*, 1994
oil on canvas
46.5 x 69 cm
Private collection, London

5
**Glenn Brown**
*Jesus; The Living Dead (after Adolph Schaller)*, 1997-98
oil on canvas
220 x 326 cm
Private collection, London

6
**Saint Clair Cemin**
*Tea Bell*, 1990
bronze
28.5 x 20.3 x 35.5 cm
The Carol and Arnold Wolowitz Collection

7
**Saint Clair Cemin**
*Tea Club*, 1993
polychrome bronze and wood
76.8 x 49.5 x 77.5 cm
© Saint Clair Cemin. Robert Miller Gallery, New York
Private collection, Washington DC

8
**Saint Clair Cemin**
*Untitled (Cut-out) (cemi-0374)*, 1993
painted wood
182.2 x 85.7 x 3.1 cm
© Saint Clair Cemin. Robert Miller Gallery, New York
Courtesy Robert Miller Gallery, New York

9
**Helen Chadwick**
*Cyclops Cameo,* 1995
cibachrome transparency, oil, dyes, plywood, MDF, glass,
electrical apparatus
180 x 140 x 12 cm
© Estate of the artist 1998

10
**Helen Chadwick**
*Monstrance,* 1996
iris print and perspex
115 x 56 x 6 cm

11
**Helen Chadwick**
*Opal,* 1996
iris print and perspex
100 x 80 x 8 cm
© Estate of the artist 1998

12
**Mat Collishaw**
*Catching Fairies*, 1994
unique colour photograph
44 x 64 cm
© the artist 1998
Collection of Thomas Dane

13
**Mat Collishaw**
*Catching Fairies,* 1994
unique colour photograph
50.8 x 76.2 cm
Simmons & Simmons

14
**Mat Collishaw**
*Catching Fairies,* 1994
unique colour photograph
50.8 x 76.2 cm
Collection of De Beers'
Central Selling Organisation

15
**Mat Collishaw**
*Soliciting a Reward,* 1994
praxinoscope: colour photographs, iron, mirrors,
wood, motor, steel, video camera, projector, tape
and tape recorder
45.7 x 45.7 x 104 cm
Collection the artist

16
**Mat Collishaw**
*Untitled (Babbling Brook),* 1995
19th-century camera, tripod and video projection
140 x 72 x 110 cm
© the artist 1998
Art & Public,
Pierre Huber, Geneva, Switzerland

17
**Jeffrey Dennis**
*News from Nowhere (Bends in the River),* 1991-92
oil, paint, and charcoal on linen
132.1 x 393.7 cm
© the artist 1998
Collection of Timothy and Anthony Hyman

18
**Douglas Gordon**
*Trigger Finger,* 1994
video installation, edition of 3
© the artist 1998
Galerie Micheline Szwajcer

19
**Douglas Gordon**
*Monster,* 1997
transmounted c-print in painted wood frame,
edition of 11
85.7 x 126.4 cm
© the artist 1998
Collection of Oliver Peyton, courtesy Sadie Coles HQ,
London

20
**Jane Hammond**
*A Parliament of Refrigerator Magnets,* 1994
oil on canvas with collage
185.4 x 222.2 cm
© the artist 1994
Private collection

21
**Jane Hammond**
*Love You in the Morning,* 1997
oil and mixed media on canvas
2 panels, 254 x 218.4 cm each
© the artist 1997
The Penny and David McCall Collection

22
**Louise Hopkins**
*Aurora 13,* 1995-96
oil paint on reverse of patterned furnishing fabric
183 x 130 cm
© the artist 1998
The Saatchi Gallery; photo: Ian Nichols

23
**Bill Jacobson**
*Interim Portrait #522,* 1993
colour coupler print (edition of 9)
50.8 x 61 cm
© the artist 1993
Courtesy Julie Saul Gallery, New York

24
**Bill Jacobson**
*Interim Couple #1098,* 1994
silverprint on paper (edition of 9)
50.8 x 61 cm
© the artist 1994
Courtesy Julie Saul Gallery, New York

25
**Bill Jacobson**
*Songs of Sentient Beings #1053,* 1994
silverprint on paper (edition of 9)
50.8 x 61 cm
Courtesy Julie Saul Gallery, New York

26
**Sally Mann**
*At Warm Springs,* 1991
gelatin silver enlargement print
60.9 x 50.8 cm
© Sally Mann, courtesy Edwynn Houk Gallery, New York

27
**Sally Mann**
*The Last Cracker,* 1991
gelatin silver enlargement print
50.8 x 60.9 cm
© Sally Mann, courtesy Edwynn Houk Gallery, New York

28
**Sally Mann**
*Child's Play,* 1992
gelatin silver contact print
20.3 x 25.4 cm
Courtesy Edwynn Houk Gallery, New York

29
**Sally Mann**
*The Virtuous Girl*, 1994
gelatin silver enlargement print
50.8 x 60.9 cm
© Sally Mann, courtesy Edwynn Houk Gallery, New York

30
**Sally Mann**
*Elizabeth's Bouquet*, 1996
gelatin silver enlargement print
60.9 x 50.8 cm
Courtesy Edwynn Houk Gallery, New York

31
**Joan Nelson**
*Wallpaper*, 1991
hand-screened and printed paper
each roll: 457.2 x 68.6 cm
Courtesy A/D Design, New York

32
**Joan Nelson**
*Untitled (#385)*, 1993
acrylic oil, powdered pigment and crackle medium on wood
25.4 x 25.4 cm
Courtesy Robert Miller Gallery, New York

33
**Joan Nelson**
*Untitled (#386)*, 1993
powdered pigment over tinted gesso on wood
50.8 x 50.8 cm
Courtesy Robert Miller Gallery, New York

34
**Joan Nelson**
*Untitled (#420)*, 1995
oil on panel
15.2 x 15.2 cm
© Joan Nelson. Robert Miller Gallery, New York
Courtesy Robert Miller Gallery, New York

35
**Joan Nelson**
*Untitled (After Friedrich Brentel 'Spring')*, 1995
gouache, acrylic & ink on paper
26 x 18.1 cm
© Joan Nelson. Robert Miller Gallery, New York
Courtesy Robert Miller Gallery, New York

36
**Joan Nelson**
*Untitled (George Caleb Bingham Amalgam)*, 1995
gouache, graphite, ink, cocoa, cinnamon and talc on paper
17.7 x 17.7 cm
Courtesy Robert Miller Gallery, New York

37
**Simon Periton**
*Doily for Christopher Dresser*, 1996
pink paper
51 x 79 cm
© the artist, courtesy Sadie Coles HQ, London

38
**Simon Periton**
*Queen Victoria*, 1997
black paper
274.5 x 274.5 cm
© the artist, courtesy Sadie Coles HQ, London

39
**Simon Periton**
*Breathless (Lilac)*, 1998
tracing paper
28 x 31 cm
© the artist, courtesy Sadie Coles HQ, London

40
**Steven Pippin**
*The Continued Saga of an Amateur Photographer*, November 1993
video and series of seven positive photographic images printed
from the original paper negative
49.5 x 74.5 cm each
© the artist 1998
Courtesy of Klosterfelde Collection, Hamburg, Germany
Photographs courtesy Gavin Brown's enterprise, New York

41
**Steven Pippin**
*The Continued Saga of an Amateur Photographer*, November 1993
model train: wood, professionally fabricated rail line
and carriages
26 x 197 x 27.5 cm
Courtesy of Klosterfelde Collection, Hamburg, Germany

42
**Lari Pittman**
*This Discussion, Beloved and Despised, Continues Regardless*, 1989
acrylic and enamel on mahogany panel
182.8 x 152.4 cm
© the artist 1989
Collection of Eileen and Peter Norton, Santa Monica
Photo: Douglas Parker, courtesy Regen Projects, Los Angeles

43
**Lari Pittman**
*Miraculous and Needy*, 1991
acrylic and enamel on mahogany panel
208.2 x 167.6 cm
© the artist 1991
Collection of George Meyer and Maria Semple
Photo: Douglas Parker, courtesy Regen Projects, Los Angeles

44
**Elliott Puckette**
*Malec*, 1993
gesso, kaolin, ink on wooden panel
152.4 x 121.9 cm
Collection Daniel Wolf, New York

45
**Elliott Puckette**
*Untitled*, 1996
ink on antique paper
45.7 x 30.5 cm
© the artist 1996
Thomas E. Delavan, New York
Photo courtesy Paul Kasmin Gallery

46
**Elliott Puckette**
*Untitled*, 1997
india ink on antique paper
42.5 x 15.2 cm
© the artist 1997
Private collection, New York
Photo courtesy Paul Kasmin Gallery

47
**Elliott Puckette**
*Untitled*, 1997
india ink on antique paper
39.4 x 15.2 cm
Collection Madison Cox, New York City

48
**Yinka Shonibare**
*Girl/Boy, 1998*
wax printed cotton textile
display stand: aluminium, plastic, felt
Courtesy Stephen Friedman Gallery

49
**Laura Stein**
*Cactaceaescobariachaffeyirebutiarainbowdragon'sbloodcelsianus*,
*1993*
photo album
21.6 x 31.7 cm
Courtesy of Basilico Fine Arts, New York

50
**Laura Stein**
*Graft Study # 12*, 1994
watercolour on xerox
76.2 x 55.9 cm
© the artist 1994
Collection of The Walt Disney Company, New York

51
**Laura Stein**
*Filled*, 1996
colour photograph
101.6 x 76.2 cm
© the artist 1996
Courtesy of Basilico Fine Arts, New York

52
**Laura Stein**
*Pair of Sylvesters*, 1996
colour photograph
21.6 x 31.7 cm
Courtesy of Basilico Fine Arts, New York

53
**Hiroshi Sugimoto**
*Earliest Human Relatives (American Museum of Natural History)*, 1994
silver gelatin print
50.8 x 60.9 cm
Courtesy Sonnabend Gallery

54
**Hiroshi Sugimoto**
*Queen Victoria* (from *Wax Museums I*), 1994
silver gelatin print
50.8 x 60.9 cm
© the artist 1994
Courtesy Sonnabend Gallery

55
**Hiroshi Sugimoto**
*The Brides in the Bath Murderer* (from *Wax Museums II*), 1994
silver gelatin print
50.8 x 60.9 cm
Courtesy Sonnabend Gallery

56
**Hiroshi Sugimoto**
*The St. Albans Poisoner* (from *Wax Museums II*), 1994
silver gelatin print
50.8 x 60.9 cm
© the artist 1994
Courtesy Sonnabend Gallery

57
**Kara Walker**
*World's Exposition*, 1997
cut paper on wall (21 elements)
304.8 x 487.7 cm
© the artist 1997
Collection Jeanne Greenberg and Nicolas Rohatyn, New York
Courtesy Wooster Gardens, NYC